IN THE SHADE OF THE TREE

IN THE SHADE OF THE TREE

A Photographic Odyssey Through the Muslim World

PETER SANDERS

THE STARLATCH PRESS
CHICAGO

MOUNTAIN OF LIGHT
LONDON

First edition published in 2002.
Printed in Turkey.
Design: CWDM

Published jointly by:

Starlatch Press
8396 South 77TH Avenue
Bridgeview, Illinois 60455 · USA
website: www.starlatch.com
e-mail: info@starlatch.com

Mountain of Light
PO BOX 7404
London N7 8JQ · UK
website: www.mountainoflight.com
e-mail: info@mountainoflight.com

Starlatch Press ISBN (USA): 1-929694-14-8
Mountain of Light ISBN (UK): 1-900675-41-2

U.S. Library of Congress Cataloging-in-Publication Data

Sanders, Peter, 1946-
 In the shade of the tree: a photographic odyssey through the Muslim world / Peter Sanders.
 p. cm.
 ISBN 1-929694-14-8 (Hardcover : alk. paper)
 1. Photography, Artistic. 2. Islam--Pictorial works. 3. Islamic countries--Pictorial works. 4. Civilization, Islamic--Pictorial works.
 5. Sanders, Peter, 1946- I. Title.
 TR654 .S25 2002
 779'.9909'097671--dc21
 2002002012

British Library Cataloging-in-Publication Data
A catalogue record of this book is available from The British Library

PREFACE

In the Shade of the Tree is the result of many years of painstaking observation of shade. The word *photographer* literally means "one who writes with light." The photographer of this volume has been "capturing shade" for decades. Shade is a sign of God. The Quran says, *Have you not considered your Lord, how He extends the shade, and had He willed He would have made it still? Then We made the sun its guide, then We withdraw it unto Us gradually.* Shade is an admixture of light and darkness. The cosmos is in fact shade, and Peter Sanders has spent a lifetime reflecting on it. If beauty is in the eye of the beholder, then these pictures are a testimony to the beauty in Sanders' eye. He uses an odd yet wondrous mechanical device that captures for one brief moment a glimpse of beauty. The pictures in this book, while only brief moments of shade written in light captured by his discerning eye, will linger on in your memory long after you have closed the book.

HAMZA YUSUF

All the major traditions confirm the
temporary nature of this life.

Describing himself in relation to the world,
the Prophet Muḥammad said,

*I am in this world like a traveler who
takes shade under a tree, only to resume his journey.*

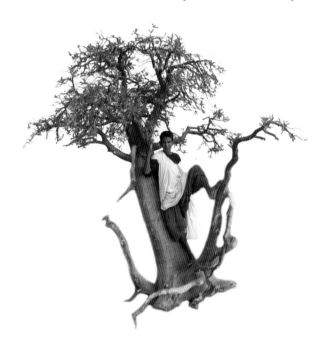

The idea of this book and its accompanying exhibition
developed after reading the above tradition. As we
shade under our own trees—large or small—we reflect
on moments and events in our lives. This book of
photographs, taken at an average shutter speed of
1/125th of a second, does not even amount to one half
of one second of worldly time, but will remain as
treasured moments for many years to come.

Peter Sanders

DOORWAY OF MYSTERY

There was a door to which I found no key,
there was a veil past which I could not see.

ʿUmar Khayyām

PAINTED DOOR IN THE OLD WALL

RABAT, MOROCCO

Rabat is a wonderful city, although I hadn't always thought so. It wasn't until I spent some time working there that I discovered its hidden beauty. I especially love the old wall that surrounds the city, and it was during an exploration of the wall that I discovered a series of old doors. This one captivated me the most.

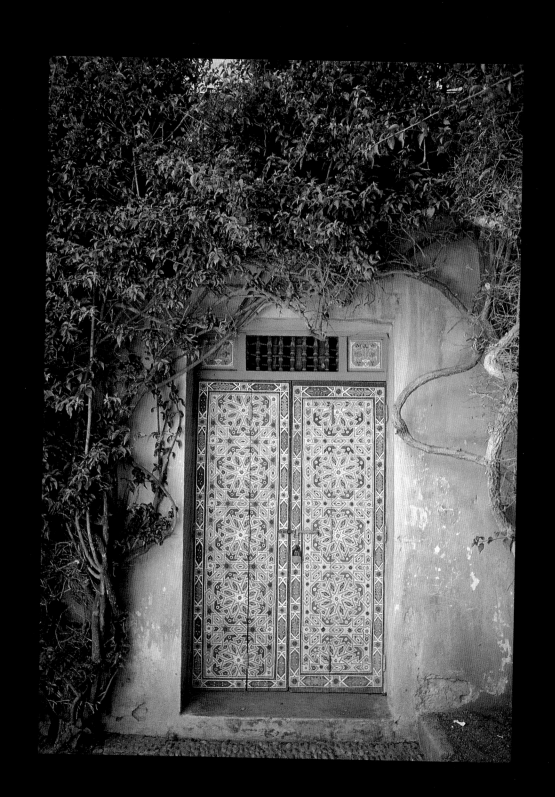

A MOMENT IN OR OUT OF TIME

A day with your Lord is as a thousand years
of what you reckon.

The Quran, 22:47

THE OLD WALL
RABAT, MOROCCO

The old wall of Rabat holds a particular fascination for me. I sat
in a café as the sun began its descent. I used the gate as stage
left and the lamppost as stage right. I then waited. Eventually a
man in traditional attire entered the setting. I knew then what I
was waiting for. The picture relates a sense of timelessness.

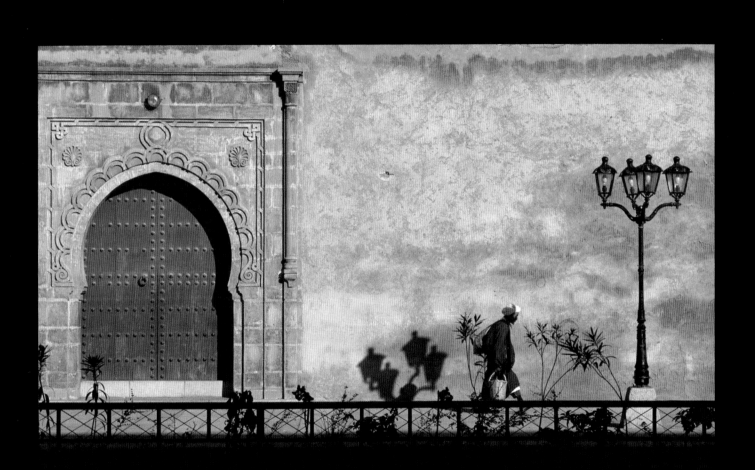

A PINK ROOM IN A MUD PALACE

Noah said, "My Lord, forgive me and my parents
and whoever enters my household a believer,
and all believing men and women."

The Quran, 71:28

QAL^CAT AL-MAGUNAH

SOUTH MOROCCO

On a journey throughout Morocco in the early 1970's, I was invited
to a meal in a mud palace in Qalͨat al-Magunah, a rose-growing
region in the northern Sahara just south of the High Atlas. The
craftsmen would sing praises of God while building these homes.
The room is a striking pink as the photo shows, with handwoven
carpets lining the floor. The wall and ceiling designs were all
painted by Imām Mulay Ḥasan, pictured here with his son.

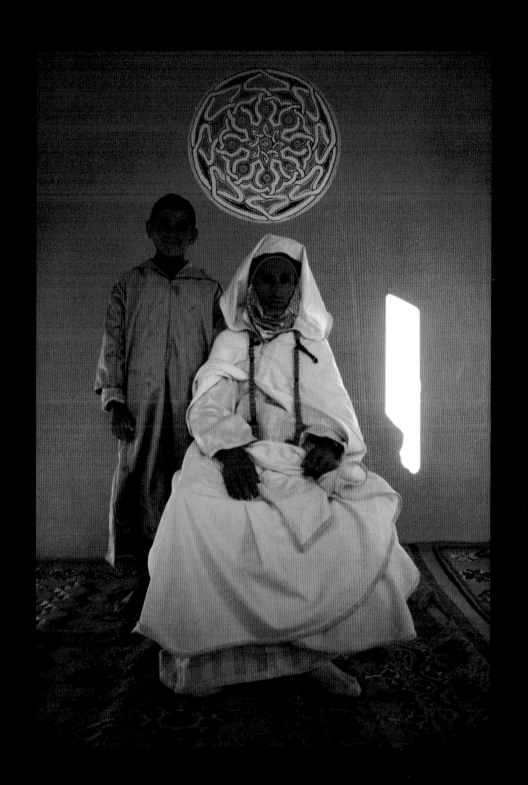

THE JOURNEY

The journey of the pilgrim is two steps and no more.
One is transcending beyond selfhood
and the other is toward nearness with the Friend.

Imām al-Shabistārī

During a recent visit to the old city of Fez, I was introduced to this old religious school. In visiting such a place, one may suddenly receive a distinct flavor of the distant past. At one time, these schools were full of vigorous students, living in small rooms, praying and studying like bees in a hive, making and gathering the nectar known as "knowledge of God."

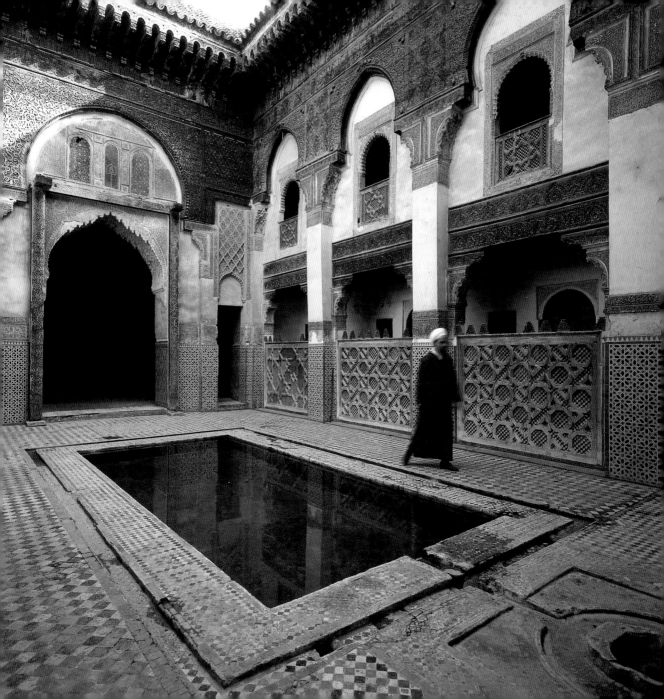

COURT OF LIONS

These are our traces that we leave behind.
They indicate who we were.
So look, after we are gone, at our traces.

Andalusian Poem

I made a trip to document Andalusian Spain, which, of course, had to include the spectacular Muslim palace in Granada known as "Alhambra." It is constantly full of visitors these days, so an enormous amount of patience is necessary when attempting to capture on film a glimpse of the majestic past. As the afternoon progresses, the Court of Lions goes through extraordinary changes of light.

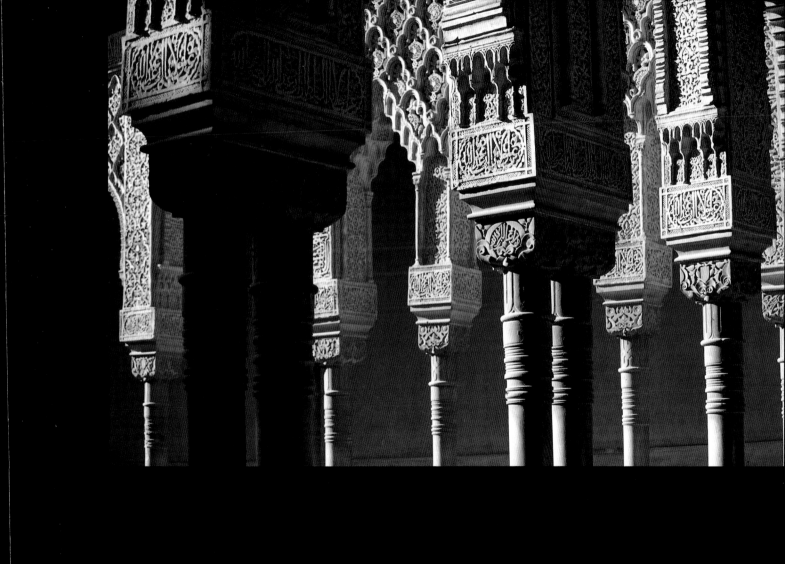

GARDENS OF ANDALUSIA

Indeed, the righteous will be amid gardens
and fountains.

The Quran, 15:45

GENERAL LIFE GARDENS

ALHAMBRA PALACE

GRANADA, SPAIN

Spending hours in the gardens of Alhambra Palace trying to capture
the spirit of the place in a photograph felt like therapy. The sound
of running water, the songs of birds, the variety of colors,
the setting sun, and the subtle stillness of it all would cause the
insane to become sane and the sane to taste ecstasy.

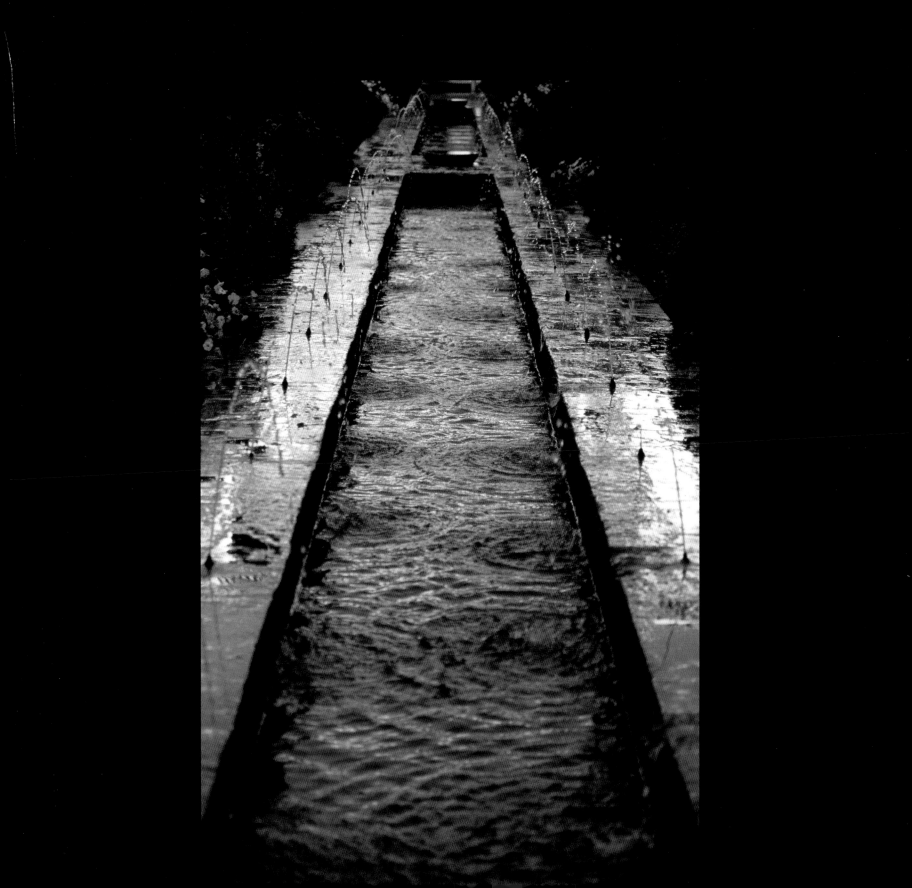

A GIRL IN GREEN

So be patient, with a beautiful patience!

The Quran, 70:5

THE DIVINITÉ MOSQUE

DAKAR, SENEGAL

WEST AFRICA

Drawn to a newly built mosque on an oceanside beach, I became aware of this young girl collecting water for its visitors. As I looked through the lens and studied her face more closely, it occurred to me that she was likely suffering from malaria, which is not uncommon in these parts. But through the transparency of her illness, I saw also an inner beauty that emanated from remarkable patience.

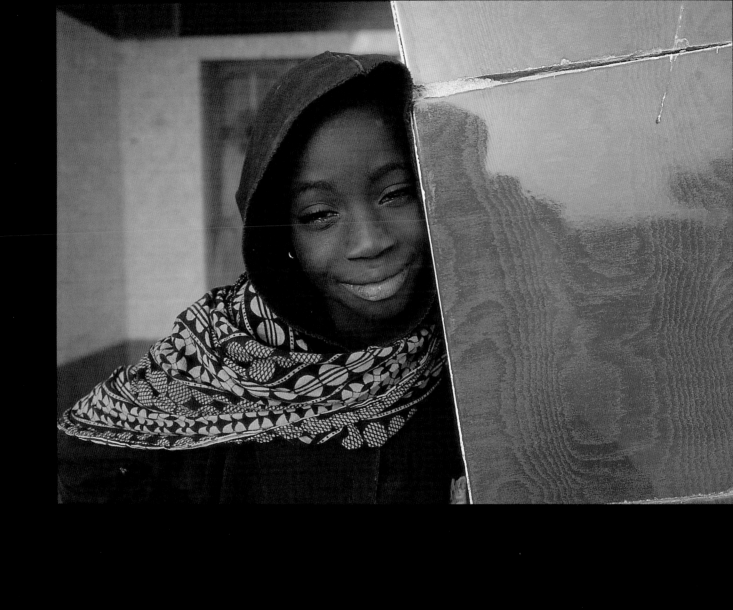

WONDERING WHAT THE FUTURE HOLDS

Reflect upon the beauty of the creation on land and sea.
Look into God's attributes both openly and secretly.
In the self and on the horizon is the greatest witness
to God's perfections, which are limitless.

Shaykh Muḥammad ibn al-Ḥabīb

SUMBUJUN BEACH
DAKAR, SENEGAL
WEST AFRICA

In Senegal, a country of poor but happy people, there is hardly a
single moment in which one does not hear the Quran recited, a song
sung, or the beat of music. On Sumbujun beach, famous for fishing,
I noticed these two boys dressed in the robes of circumcision gazing
out to sea, perhaps contemplating their future.

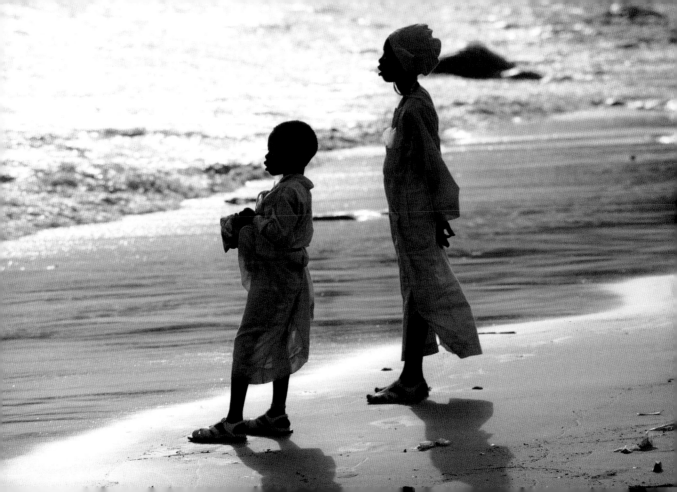

DESERT SOLITUDE

That serene place belongs to the one occupied
with the correction of his own self
who struggles against it in every state.

Shaykh Muḥammad ibn al-Ḥabīb

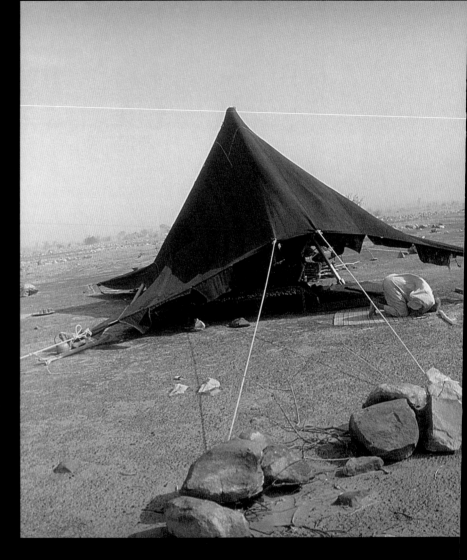

THE DESERT OF MAURITANIA

SAHARAN AFRICA

We spent three days and nights in this remote place in the
desert—nights in which the winds blew and covered us with a
thin layer of sand. Meanwhile, Shaykh ʿAbd al-Rahmān prayed.

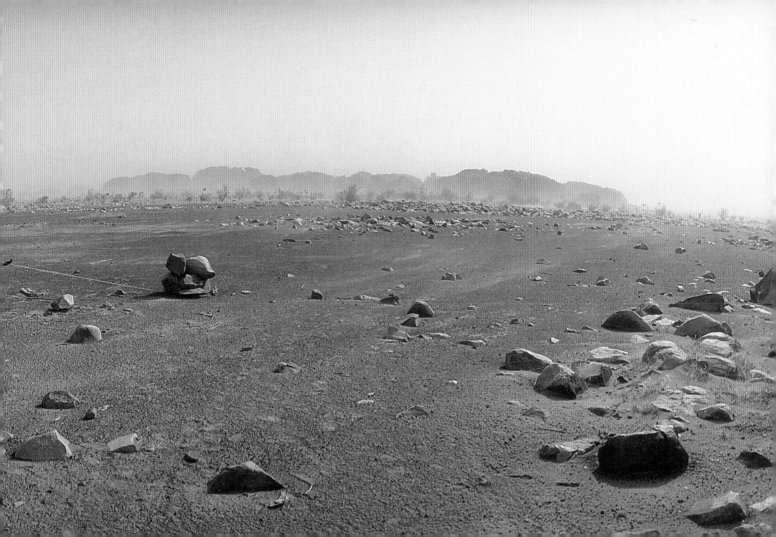

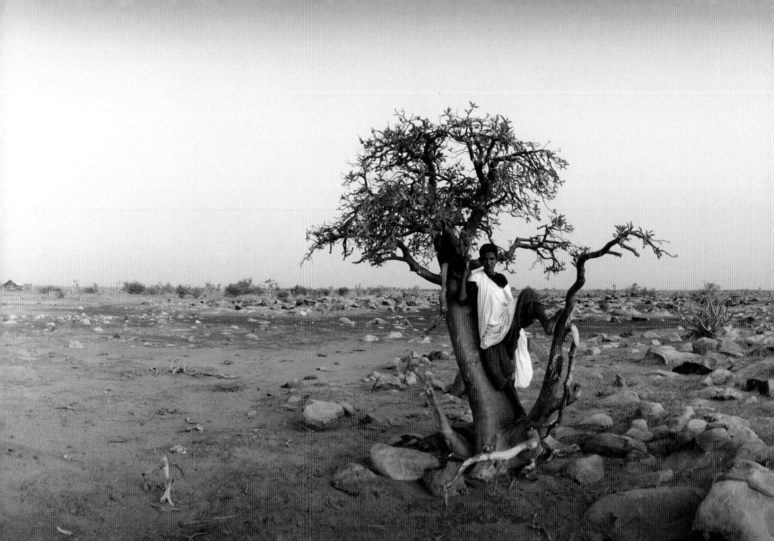

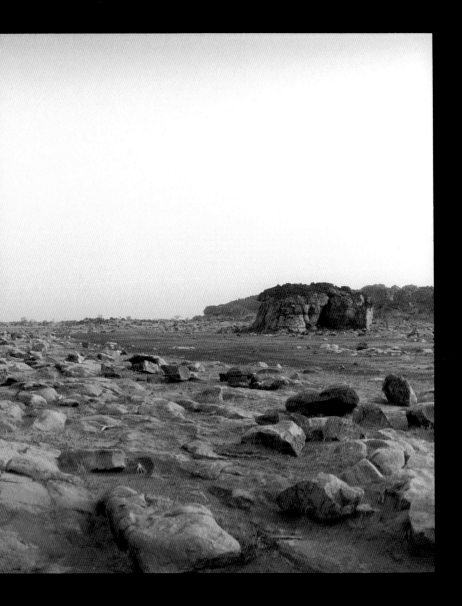

IN THE SHADE OF THE TREE

Have you not considered your Lord, how He extends the shade, and had He willed He would have made it still? Then We made the sun its guide, then We withdraw it unto Us gradually.

The Quran, 25:45–46

LAHSIRA, MAURITANIA

the desert, anything that offers any shade is a blessing and is greatly reciated. Each tree of the desert of Mauritania is a unique sculpture.

THE INVISIBLE THREAD LINKING
STUDENT AND TEACHER

Indeed, the angels lower their wings for the seeker
of sacred knowledge, pleased with what he is doing.
The creatures in the heavens and the earth seek
forgiveness for the student of sacred knowledge,
even the fish in the sea.

The Prophet Muḥammad ﷺ

UNIVERSITY WITHOUT WALLS

THE DESERT OF MAURITANIA

SAHARAN AFRICA

On a journey deep into the Mauritanian desert, I was brought
into the presence of this great teacher. He sleeps little, eats
little, and spends his days serving his students. The students
study hard all day every day. Their relaxed postures here are not
regarded as impolite but are a means of helping them to
maintain concentration during long periods of continuous study.

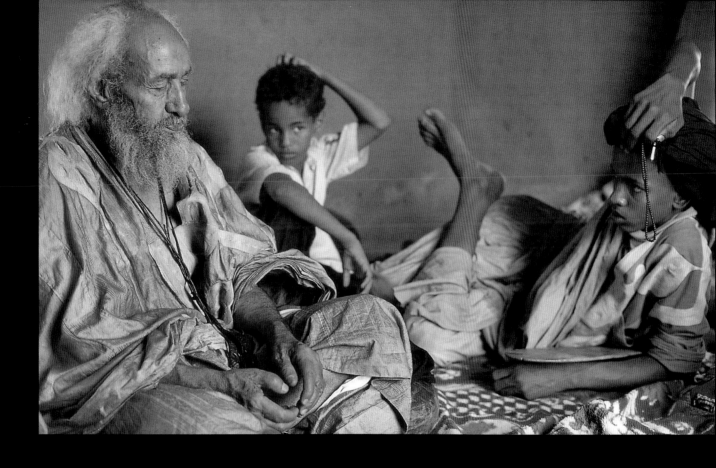

THE WEALTH OF POVERTY

The scholars are the heirs of the prophets.
The prophets leave no money as a bequest.
Rather, they leave knowledge.
Whoever seizes it has taken a bountiful share indeed.

The Prophet Muḥammad ﷺ

The students of Twemerit are full of light and are unsnared by
the material world. I asked the one on the left to pose for me.
Self-conscious about his shaven head, he was shy and reluctant.
I assured him that it made him look noble. He eventually agreed
as long as I included his friend. They carry the boards with them
wherever they go, using every spare moment to learn whatever
they are studying, whether it is the Quran, Sacred Law, or any
of the other Islamic sciences.

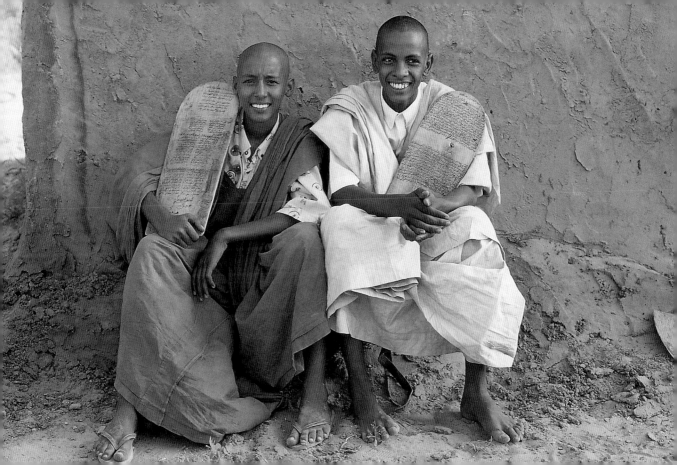

INSTANT WISDOM

A man's wisdom makes his face to shine.

<div align="center">Ecclesiastes, 8:1</div>

<div align="right">

THE DESERT OF MAURITANIA

SAHARAN AFRICA

The qualities of timelessness and concentration enable the
desert children to play for hours with such things as a small
piece of sheep's fur—no computers or television, in fact, no
electricity. When I once again met this boy, now matured into a
young man, I noted that there was still no beard, though a
certain nobility and wisdom was growing in his heart.

</div>

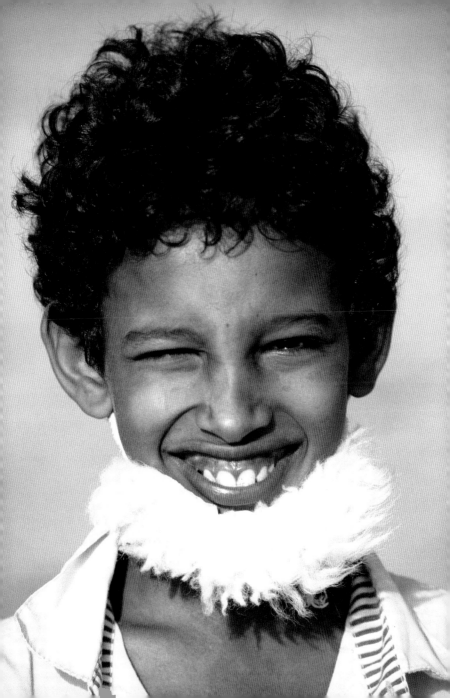

THE MASTER OF THE TIMES

What good is an increase in wealth when life grows ever
shorter? So be joyous only for an increase in knowledge
or in good works, for they are your two companions
that will accompany you in the grave when your family,
wealth, children, and friends stay behind.

<div align="right">

Imām Abū Ḥāmid al-Ghazālī

</div>

<div align="right">

THE DESERT OF MAURITANIA

SAHARAN AFRICA

A memorizer of the entire Quran, Shaykh Muḥammad ʿAlī is
known also as the Master of the Times. This title is given to
special people who are able to tell when the time of any of the five
daily prayers has arrived, without the aid of any device other than
a stick and the length of its shadow. He can also tell which day it
is by the movement of the stars. He has a very lovable personality,
and one feels strongly drawn to his company.

</div>

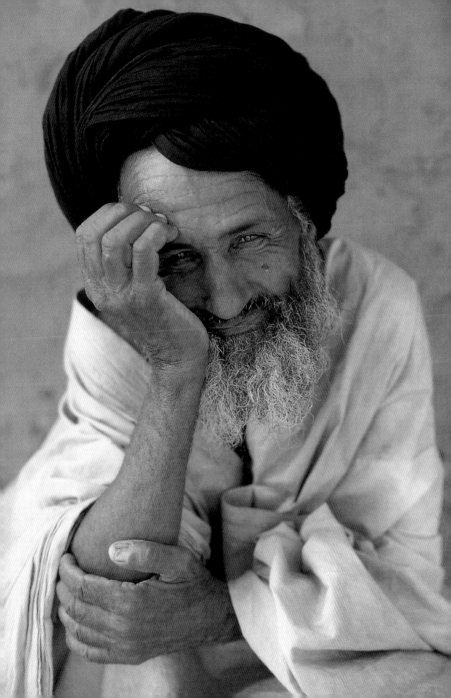

THE LIGHT OF KNOWLEDGE

The pleasure of life is only in the company of the *fuqarā'*,
who have recognized their spiritual poverty in relation
to God. They are the true sultans, masters, and princes.

Shaykh Abū Madyān

THE DESERT OF MAURITANIA

SAHARAN AFRICA

After driving for many hours through the Mauritanian desert,
we arrived at the tent of this great scholar, Shaykh Aḥmad Fāl, a
completely unpretentious gentleman who sat surrounded by his
books. He was a gracious host. As our visit concluded, we asked
if there was anything he needed. His reply: "Just a small mud
building to protect my books. Every time there is a sand-storm,
my books are ruined!"

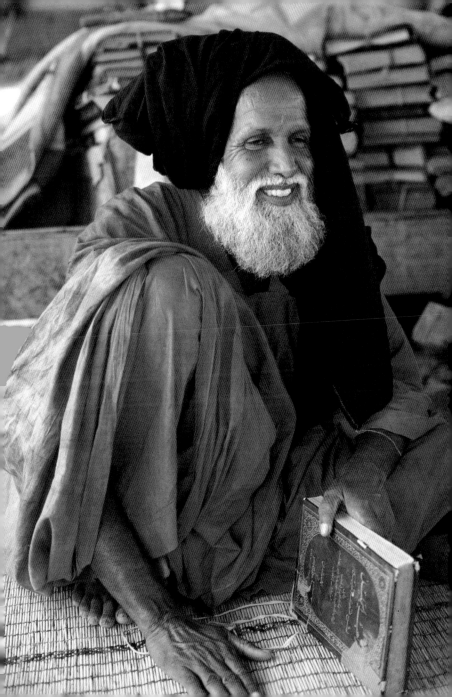

THE BEST BIRTHDAY PARTY
IN THE WORLD

Take delight in hearing of his good character and
qualities and evoke his virtue.

<div style="text-align:center">Shaykh Muḥammad ibn al-Ḥabīb</div>

SMALL BOYS CELEBRATING THE BIRTHDAY
OF THE PROPHET MUḤAMMAD ﷺ
LAMU ISLAND, KENYA
EAST AFRICA

I had wanted to visit the Island of Lamu from the early 1970's after a
Dutch painter had described it to me as "paradise on earth." There are
no cars on the island except one, belonging to the District
Commissioner, and no roads except one, the one running from the
District Commissioner's house to his office. I had the good fortune to be
there during the celebrations of the birthday of the Prophet
Muḥammad ﷺ, a joyous time. I was amazed by the purity and beauty of
the people. After the Friday Prayer, the elders of the community lead a
procession through the old streets of Lamu, reciting prayers as they walk
along. They end up at the tomb of the great spiritual sage of the island,
Ḥabīb Sahlī, and there they sit—in vast numbers
with their banners flapping in the cool
sea breezes—supplicating God.

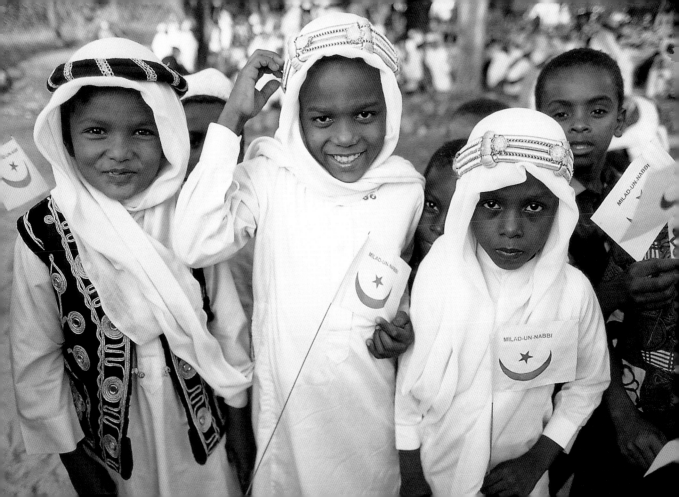

CATCH THE MOMENT

The world is but a moment,
so make it a moment of obedience.

Imām al-Shāfi'ī

During the Quran recitation competition, featured at the end of
the celebration of the Prophet's birthday on the Island of Lamu,
I found these three girls in front of me. When I lifted the
camera to my eyes and began focusing, the girls had adopted this
great pose. I would love to know what they were saying.

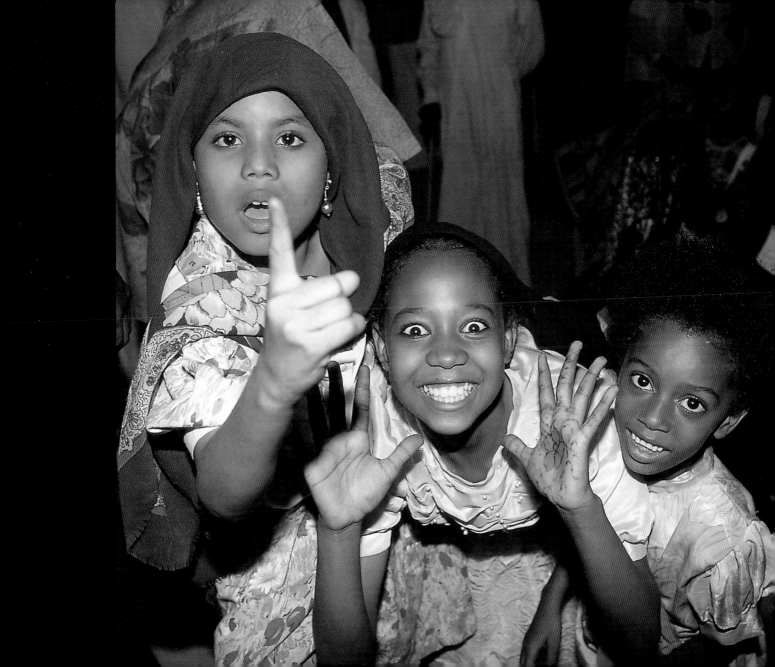

THE PLAY OF WATER, LIGHT, AND FRIENDSHIP

A friend is not a true friend unless
he protects his friend in three situations:
in his misfortune,
in his absence,
and at his death.

<div align="right">ʿAlī ibn Abī Ṭālib</div>

<div align="right">

TUTTI ISLAND

KHARTOUM, SUDAN

Near the end of my journey in Sudan, the Sudanese government
decided to put me up in the Khartoum Hilton. High up in my
room, I had a spectacular view of the Nile. One day, I saw children
washing horses in the river, so I grabbed my cameras and ran down
to them. By the time I reached the other side of the river via the
ferry, they had disappeared. However, just before sunset that
evening, I noticed these two girls hand in hand, playing,
silhouetted against the river. I felt very fortunate to have been able
to capture this quiet sense of love and sisterhood.

</div>

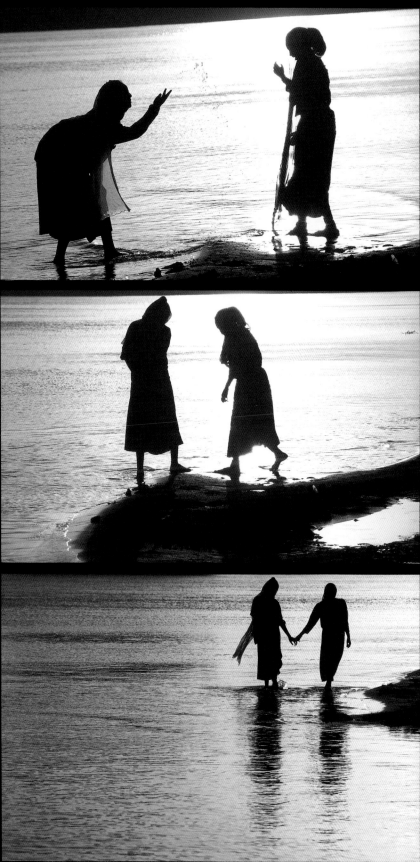

SQUEEZING IN THE FRAME

God is beautiful and He loves beauty.

The Prophet Muḥammad ﷺ

During my travels through Sudan, I was taken to the Muna Salamat al-Daʿwa School. I was completely won over by the vibrancy of the school children and the amazing atmosphere within the school. I hope I captured some of it in this portrait of the girls.

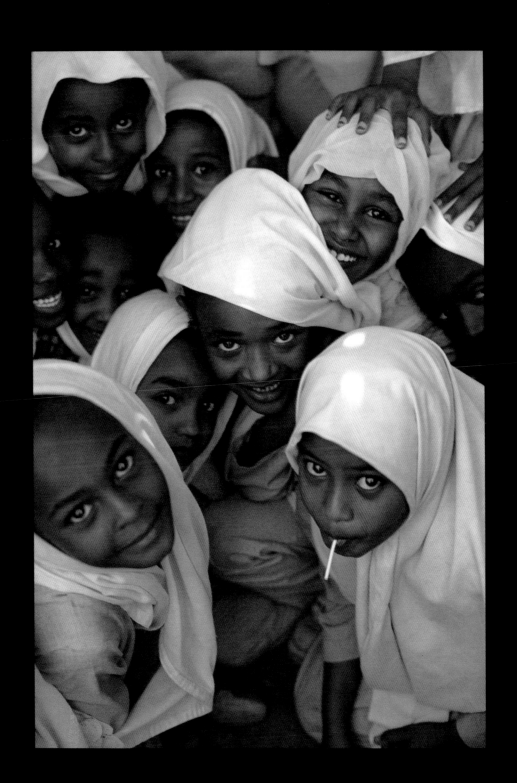

GOD IS MY PROTECTOR

The heart is made serene by His remembrance,
so that it is stilled from fear of anything in creation
and of poverty.

Shaykh Muḥammad ibn al-Ḥabīb

QURAN SCHOOL IN MWEHLI REFUGEE CAMP

DESERT OUTSIDE KHARTOUM, SUDAN

During the 1980's, I completed a tour of many of the refugee camps in Sudan at the time of the drought. This particular camp was outside Khartoum (Sudan's capital), but it felt like the middle of nowhere. It was full of nomads from the Dafur Region. After seven years of drought, these noble people were truly suffering. They had lost all their livestock and were forced to move from their lands, ending up in this wasteland. There was immense hardship. Aid was present but in very small amounts. Despite all this, the education of the children was always maintained and each camp had established its own Quran school.

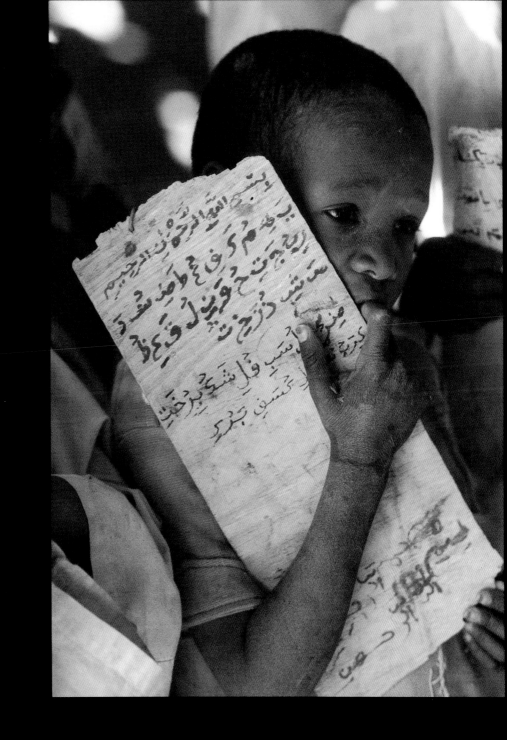

TOMB OF A SPIRITUAL SAGE

It is God who gave you life,
then He will cause you to die,
then again He will give you life
in the Hereafter.

The Quran, 22:66

During one of my early visits to Sudan, I was traveling to visit
the Mwehli Refugee camp outside Khartoum. As we drove across
the barren landscape I came across this unusual tomb. I shouted
for the driver of the Jeep to stop. Despite the delay,
the passengers patiently waited while I took a few pictures
before climbing back in to proceed to the camp.

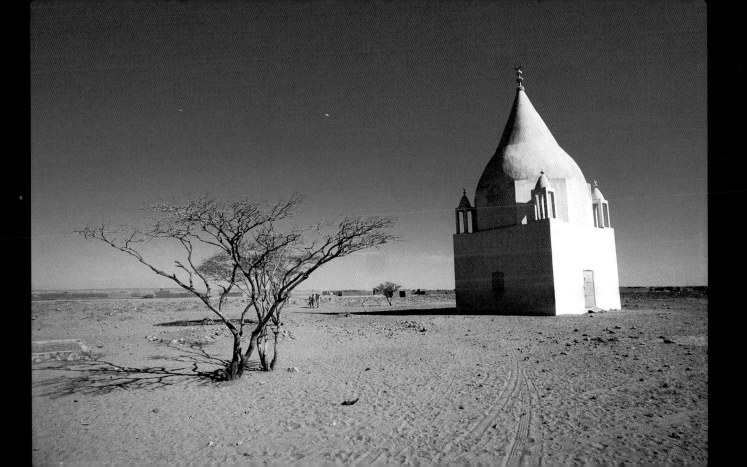

COMPANIONS

None of you believes perfectly until he loves for his
brother what he loves for himself.

The Prophet Muḥammad ﷺ

When photographing the River Nile one evening, I looked
around and saw these three boys closely watching me. I noticed
each one was a different shade of brown, and when I asked them
their names, I was told, "Abū Bakr, ʿUmar, and ʿAlī," which
happen to be the names of three of the closest companions to
the Prophet Muḥammad ﷺ fourteen centuries ago.

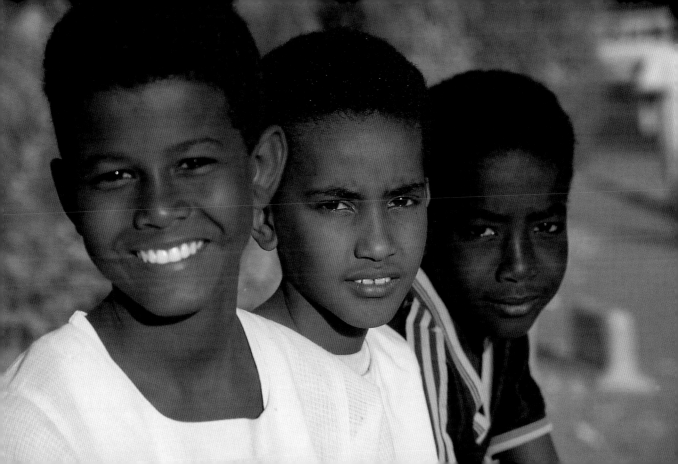

THE PRAYING MAN

Remember Me, and I shall remember you.

The Quran, 2:152

I am always aware that good photographs are a gift from God and none more than this one. On a visit to Egypt, I traveled south to Luxor, to the small village of Gourna on the far side of the Nile. As I left the traditional mosque designed by the well-known architect Ḥasan Fatḥī, I glanced back and saw this image of a Muslim praying. Before him inscribed on the wall is the simple divine name of God, "Allah." I was immediately struck by the simplicity of Islam. I took two frames, and this is one of them. This particular picture suggests the solitude of the spiritual path.

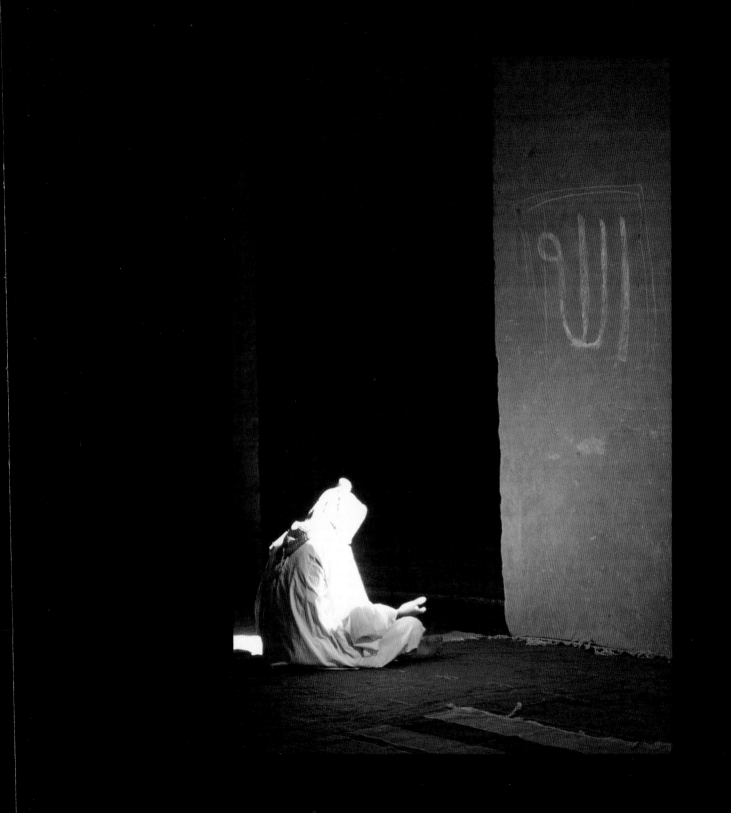

THE ASPIRATION OF MAN

Hand over your affairs to the One who knows best,
for He is the knower of every heart and every desire.

Shaykh Muḥammad ibn al-Ḥabīb

MOSQUE OF SULTAN AḤMAD

ISTANBUL, TURKEY

Sultan Aḥmad Mosque is also known as the "Blue Mosque." While taking this picture on a recent visit, I was reflecting on how this spectacular building arose from the inspiration and vision of one man, the remarkable architect Sinān. It was at this moment that a worshipper stepped into my camera's frame and began supplicating God, giving the image scale, purpose, and much more meaning.

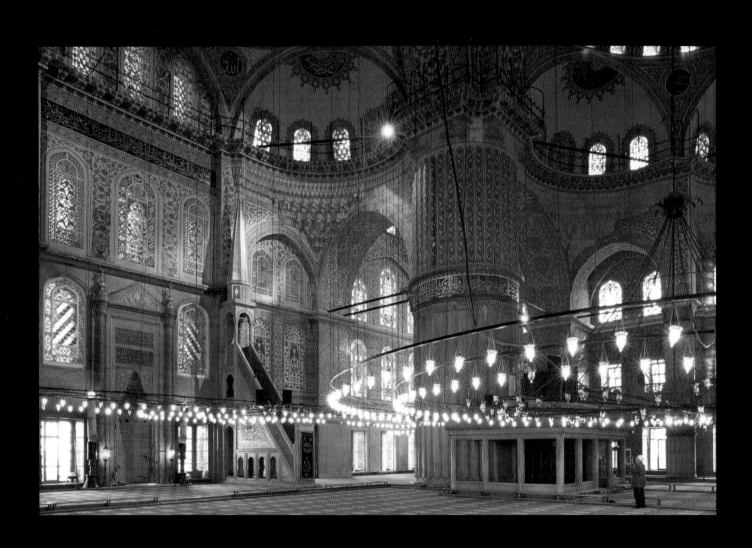

SUNSET OVER
AN ANCIENT LAND

His is the sovereignty of the heavens and the
earth, and to Him will all matters return. He
causes the night to pass into the day and the
day to pass into the night.

The Quran, 57:5–6

ISHAQ PASHA PALACE

DOGUBEYAZIT, TURKEY

Thirty-five kilometers from the Iranian border lies
Dogubeyazit. Overlooking the town is the Ottoman Palace
fortress of Ishaq Pasha. From this vantage point, one gazes over
Mount Ararat, the great snow-capped peak.

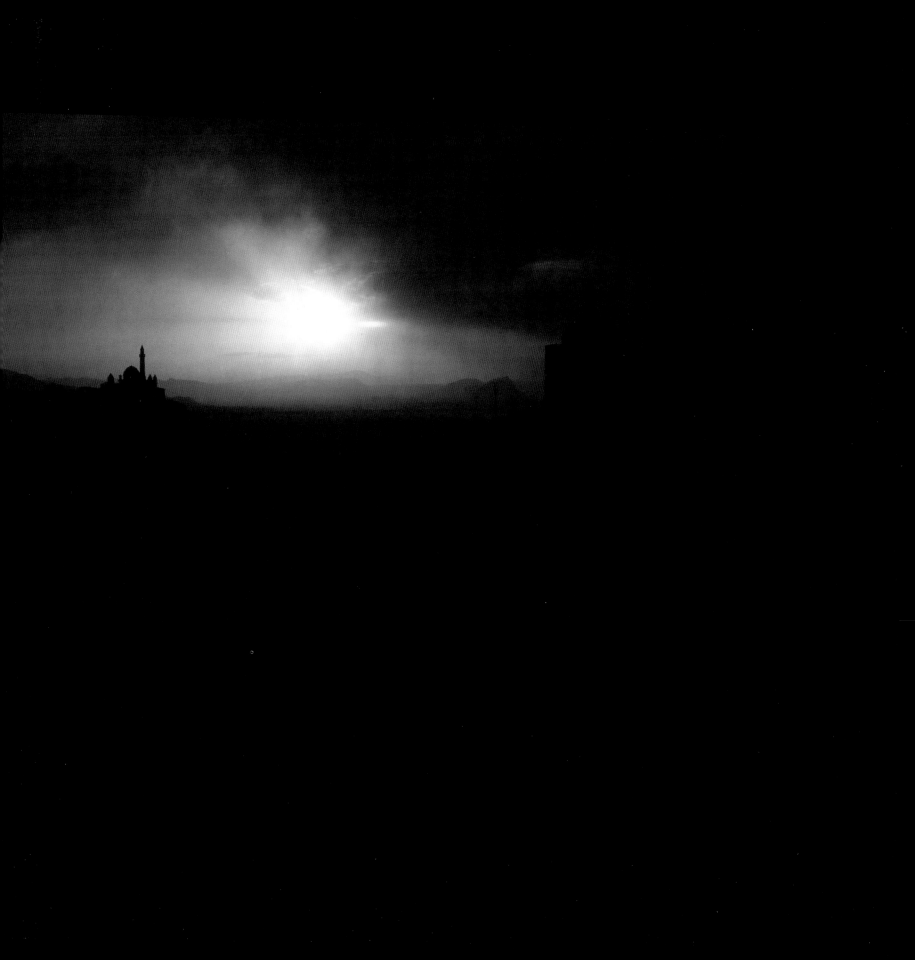

MINARET OF ARARAT

It was said, "Earth, swallow up your water!"
and "Heaven, hold back your rain!"
And the water subsided and the affair was concluded,
and the Ark came to land on al-Jūdī.

The Quran, 11:44

DOGUBEYAZIT, TURKEY

Mount Ararat, where traditionally Noah's Ark is believed to
have come to rest after the Flood, is an impressive landmark on
the Silk Route. But there is now archeological evidence of a
great boat on Mount Jūdī, another mountain nearby as
described in the Quranic passage above.

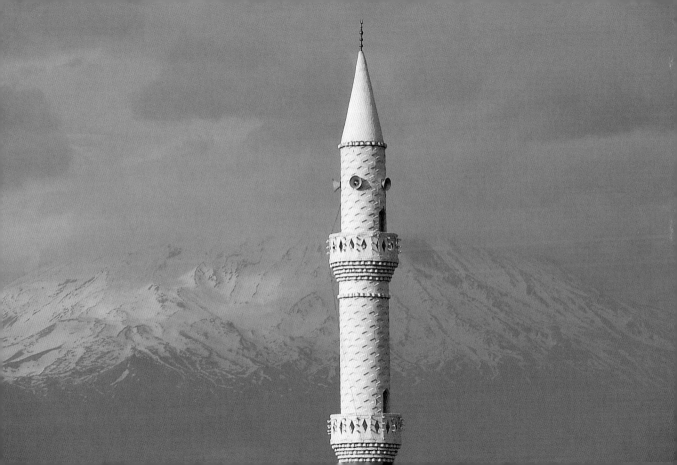

LIGHT AND SHADE

Without physical light,
we would not be able to define shades,
hues, and colors.
Without the divine aspect of light,
we would not be able to discern
between right and wrong.

MASJID-I-IMAM

ISFAHAN, IRAN

I have waited thirty years to visit Isfahan, particularly the
Masjid-I-Iman. Imagine my disappointment when I found it under
renovation. This narrowed my work to detail rather than panoramic
views. This picture suggests different worlds juxtapositioned.
I like the idea of a hidden world woven with Arabic calligraphy.

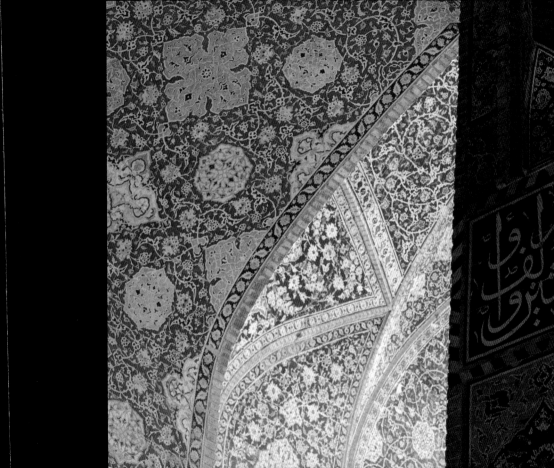

THE ASPIRATIONS OF THE SCHOLAR

God took Muḥammad by night, after his mission had
begun, to within two bows' length or nearer, until he
achieved his heart's desire.

Shaykh Muḥammad ibn al-Ḥabīb

Stairs have been a visual fascination for me. I placed myself at the
base of the stairs ascending to the Dome of the Rock itself. The light
was dropping slowly and the mood was changing as I saw this scholar
starting to climb the stairs on his way to the mosque to pray.

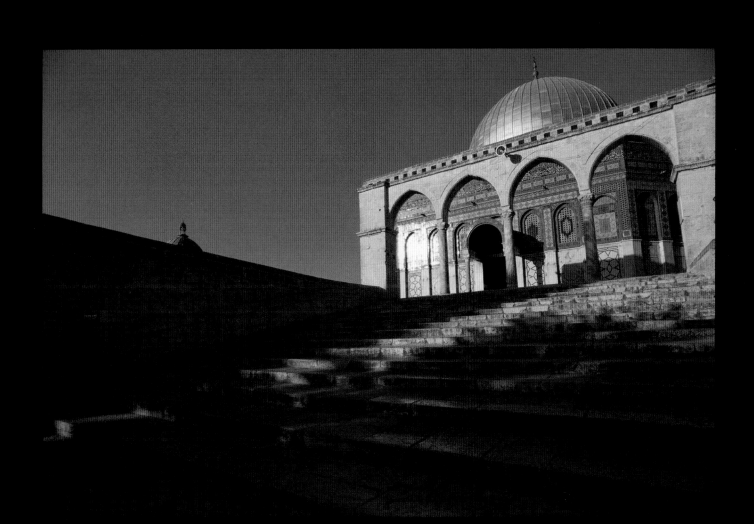

THE NOBLE SANCTUARY

Glory be to Him who took His servant, Muḥammad,
on a journey by night from the Sacred Mosque in
Makkah to the Furthest Mosque in Jerusalem,
whose surroundings We have blessed in order
to show him some of Our signs.

The Quran, 17:1

DOME OF THE ROCK

AL-AQSA MOSQUE COMPLEX

JERUSALEM

Having photographed Makkah and Madinah, I longed to
photograph Jerusalem to complete the three holy sites. This finally
happened in 1994 when a colleague working on a project regarding
the al-Aqsa Mosque Complex invited me to accompany him. We
were given access to all the areas. I cannot begin to describe my
awe in exploring this historic site. The entire 36th chapter (sura)
of the Quran is calligraphed around the top of the Dome of the
Rock. The blue of the sky with the blue of the stone is offset
with the faint moon appearing in the top left corner.

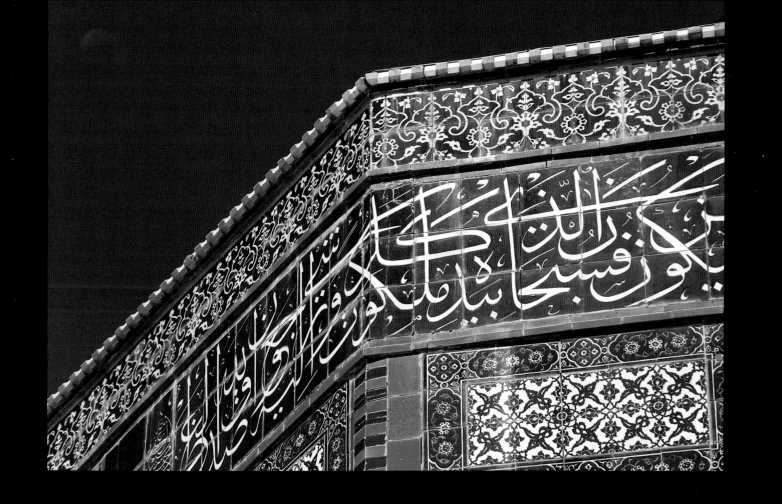

SHELTER FROM THE STORM

Make your concerns one,
and by Him all your needs will be met,
and you will enter into His protection.

Shaykh Muḥammad ibn al-Ḥabīb

AL-AQSA MOSQUE

JERUSALEM

The al-Aqsa Mosque Complex is deservedly known as the
"Noble Sanctuary." Every morning while photographing there,
we would find Shaykh Muḥammad, who traveled daily from a
village some miles away, sitting and reading the Quran
from dawn until noon.

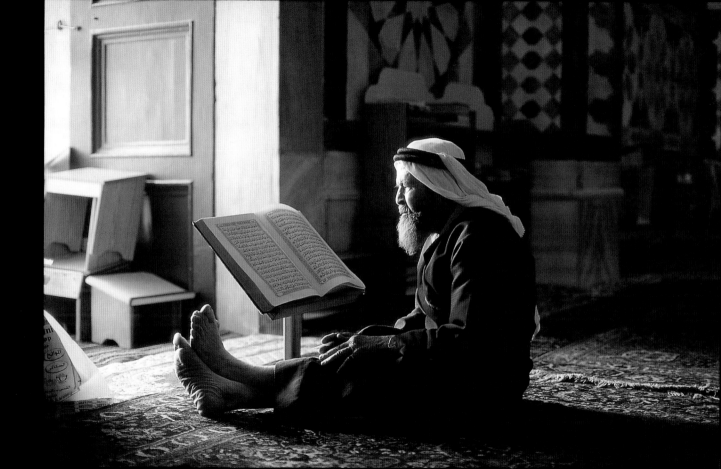

PRAISING THE ONE WORTHY OF PRAISE

Praise is due to You,
in number as great as the drops of rain,
the grains of sand, the pebbles,
the plants of the earth,
and the fish in the sea.

Shaykh Muḥammad ibn al-Ḥabīb

THE NAFUD DESERT
KINGDOM OF SAUDI ARABIA

I love the desert. Although I had made many visits to Saudi Arabia, I had never been to a desert with such rich rolling dunes. When I was in the region of Qassim, someone offered to drive me into the Nafud Desert in the late afternoon, a favorite time for photography. After about 60 kilometers, there we were among enormous sand dunes. There are times in photography when images take on an abstract nature, and as I looked into the dunes I began to see Arabic calligraphy. The stillness and the purity of the moment were soon disturbed, however, when a dune buggy appeared in my view-finder and headed straight for me.

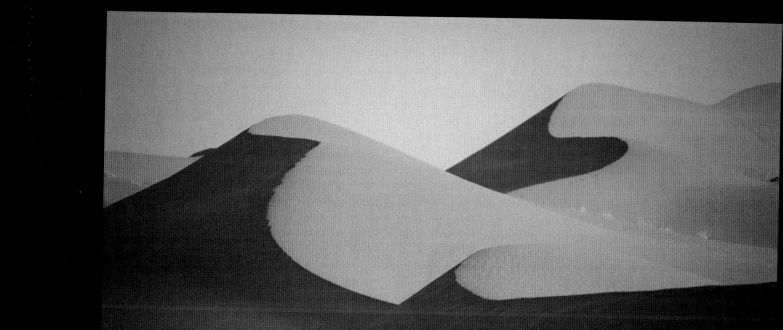

DISAPPEARING WORLDS

And We sent down from the sky water in measured
quantity, and We lodged it in the earth, and We are
well-able to take it away. Then We produced for you
therewith gardens of date-palms and vines, in which
there is abundant fruit that you may eat thereof.

The Quran, 23:18–19

NAJRĀN

KINGDOM OF SAUDI ARABIA

On my first visit to Najrān in Saudi Arabia, which is on the
border of Yemen, I had expected this oasis to be full of
traditional houses. Unfortunately, I had to search hard to find
one that was not damaged or about to collapse. Most of these
beautiful houses are now being replaced by
modern breeze-block structures.

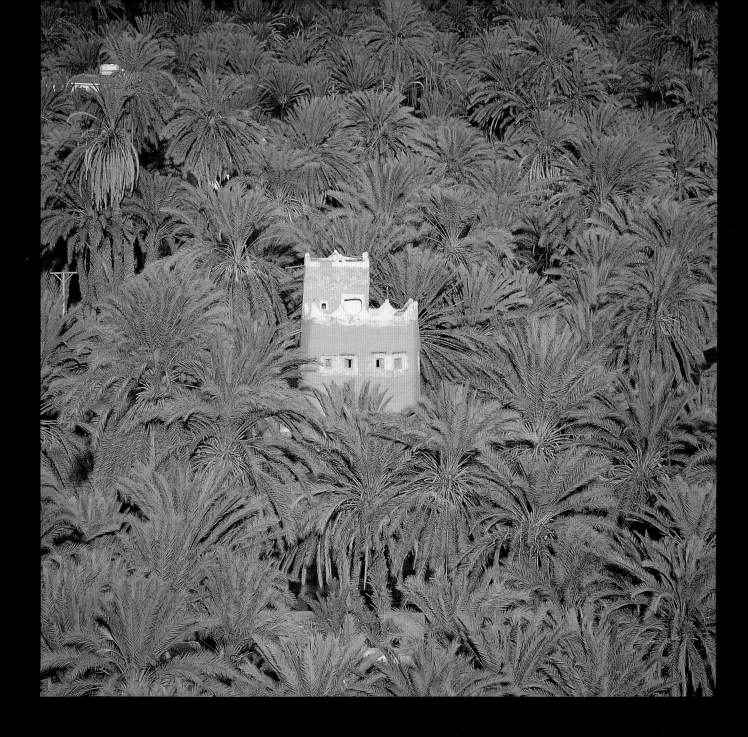

MINARET OF MIQĀT MOSQUE

We have seen you turning your face toward the heaven.
We will surely turn you towards a direction which will
please you.

The Quran, 2:144

MADINAH THE ILLUMINATED
KINGDOM OF SAUDI ARABIA

I am full of appreciation for the mosques designed by Abdul
Wahid Wakeel, a student of the great and accomplished
architect Ḥasan Fatḥī. Abdul Wahid Wakeel redesigned
Qiblatayn, Qubā', and Mīqāt Mosques and designed some of
the new mosques along the Jeddah Corniche. His simple soft
lines play with light and shadow, and this creates a wonderful
atmosphere within the mosques throughout the day.

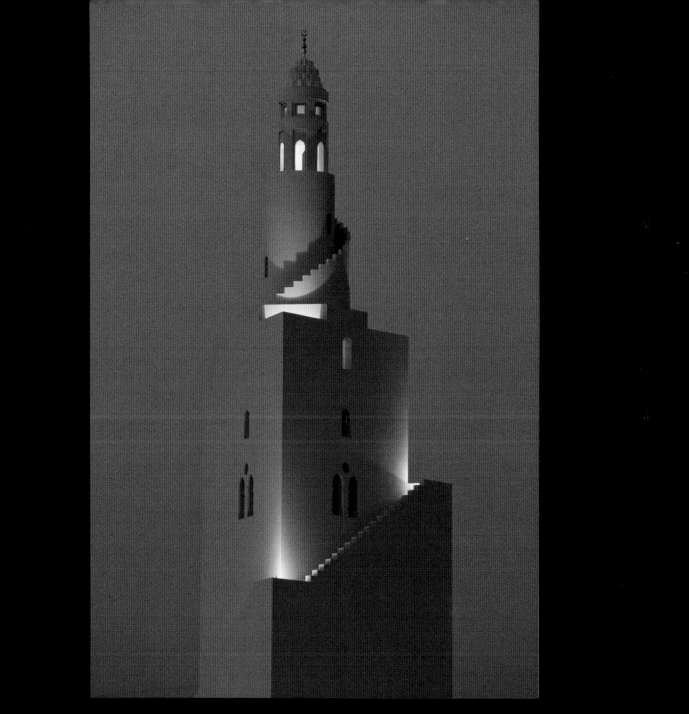

RAMADAN MOON

And they ask you about the new moons. Say they are a means
for people to tell time and to determine the Pilgrimage.

The Quran, 2:189

ROAD TO MAKKAH

KINGDOM OF SAUDI ARABIA

During a solitary drive from Madinah to Jeddah early one
Ramadan morning, this spectacular colored sky revealed itself
like a vision on the horizon.

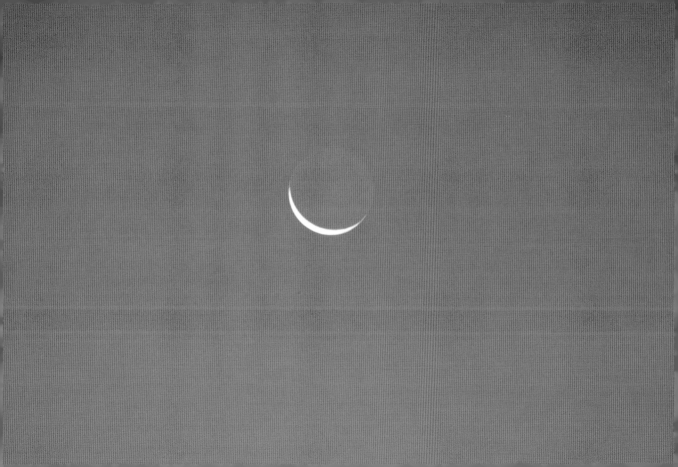

THE KISWA

Behold! Abraham and Ishmael raised the foundation of
the House; they said, "Our Lord, accept this from us.
Indeed, You are the Hearing, the Knowing."

The Quran, 2:127

THE KAʿBA

MAKKAH THE NOBLE

KINGDOM OF SAUDI ARABIA

The black cloth or *kiswa*, embroidered with gold inscriptions,
veils the Kaʿba, the sacred building in Makkah that is considered
to be the geographical heart of Islam and the direction toward
which Muslims pray. Once a year on the Day of ʿArafāt during
the Hajj, the black cloth is changed. This procedure takes most
of the day to complete, and at no point is the Kaʿba entirely
uncovered. It is performed very modestly, putting on the new
cloth while slipping out of the old.

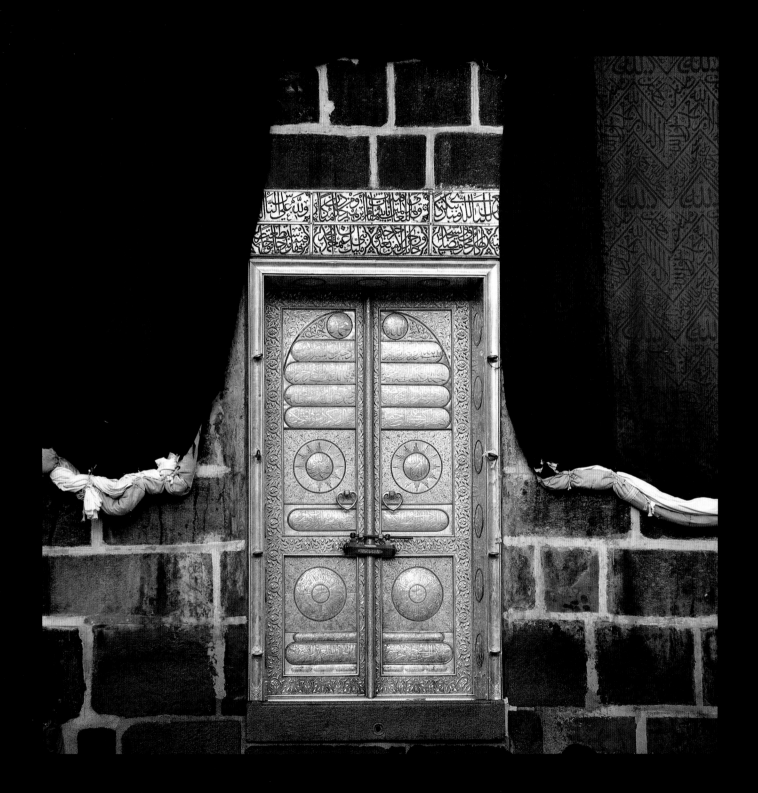

THE MYSTERY OF THE KAʿBA

Likened to the believer's heart which he orbits
constantly, veiled from its interior, the mystery
continues to draw us like bees to nectar.

When you are near the Kaʿba in Makkah, you feel that you are at the
heart of the world. Built by the Prophet Abraham ﷺ, the Kaʿba is
illuminated by the light of the people who go around it. On my first
visit in 1971, I was immediately struck by the size of it. It completely
filled my vision. This gave me the idea for this particular image.

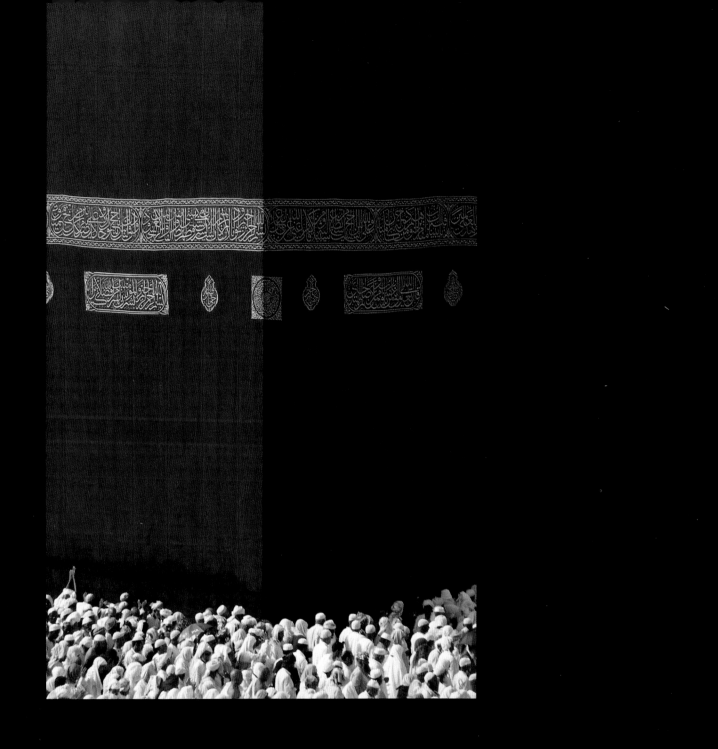

AN ANGEL'S VIEW

And We have made the House a place of assembly for
the people and a place of safety.

<div align="center">

The Quran, 2:125

</div>

SANCTUARY OF THE KAʿBA

MAKKAH THE NOBLE

KINGDOM OF SAUDI ARABIA

On the eve of the Eid festival at the end of the month of
Ramadan, I found myself placed on one of the highest buildings
in Makkah. The Holy City was filled to the brim with
worshippers. The unbroken mass of people stretched as far as the
eye could see. When they finally prayed the Eid prayer just
after sunrise, they appeared like one body.

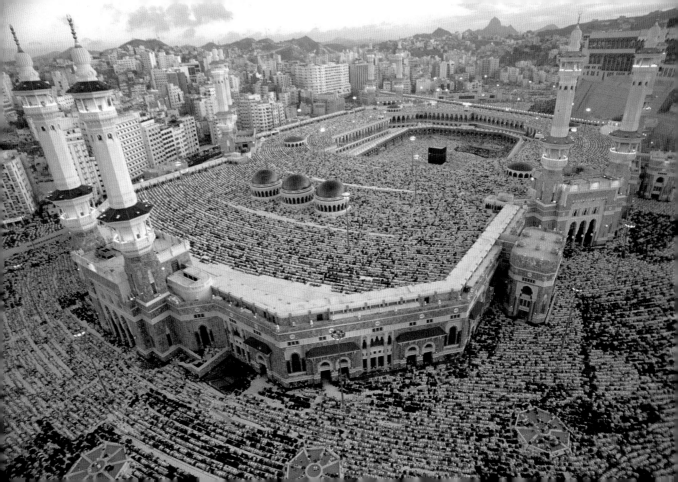

THE ILLUMINATED CITY

The full moon has come upon us.

From a song for the Prophet Muḥammad ﷺ
sung upon his triumphant return to Madinah

The Eid Prayer in Madinah, a city 300 miles north of Makkah, is
a spectacular event in itself. Established in our high vantage
point, from before dawn, we patiently waited while
the worshippers quietly gathered.

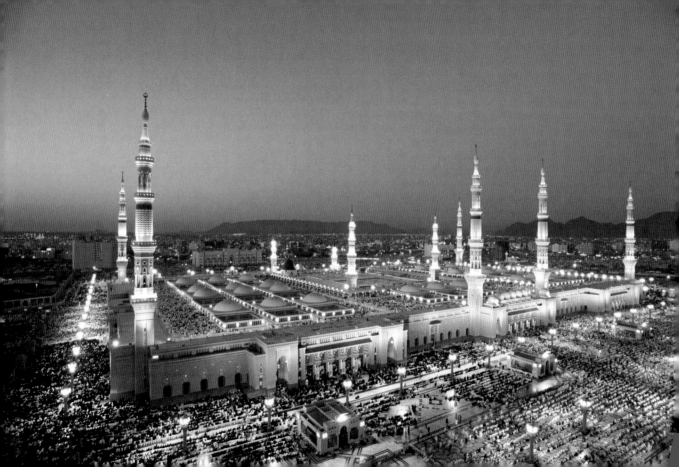

THE VISIT

All whose journeys end at the house of a generous host
get what they ask for, even their most extreme desires.

Shaykh Muḥammad ibn al-Ḥabīb

This location, initially the humble house of the beloved Prophet Muḥammad ﷺ, established as a mosque for more than 1400 years, has undergone many changes. Some of the greatest changes have been in recent years. These include sliding domes, a vast complex air-conditioning system, and materials imported from all over the world, built by craftsmen from many nations. At the heart of this now immense building lies the old Ottoman section of the mosque with its distinct green dome surrounded by its smaller silver irregular domes.

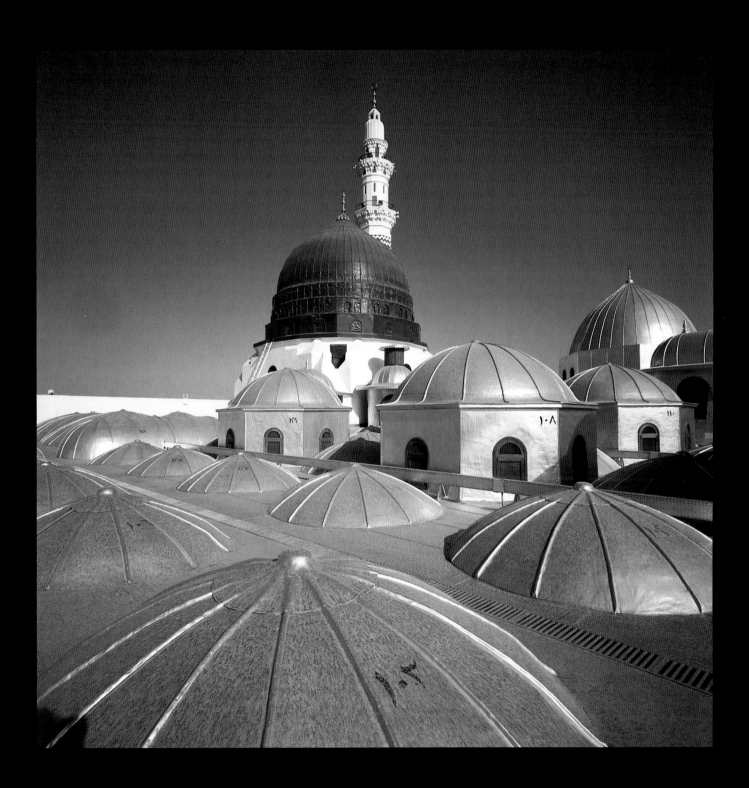

BENEATH THE CANOPY

By night you soared from sanctuary to sanctuary just as
the resplendent moon moves across the night sky
illuminating gloomy darkness.

From *The Burda* of Imām al-Buṣayrī

THE GREEN DOME AT NIGHT
THE PROPHET'S MOSQUE
MADINAH THE ILLUMINATED
KINGDOM OF SAUDI ARABIA

Beneath the canopy of the green dome lies the burial place of the
Prophet Muḥammad ﷺ, loved by Muslims the world over. Madinah the
Illuminated holds a special place within the hearts of the believers.

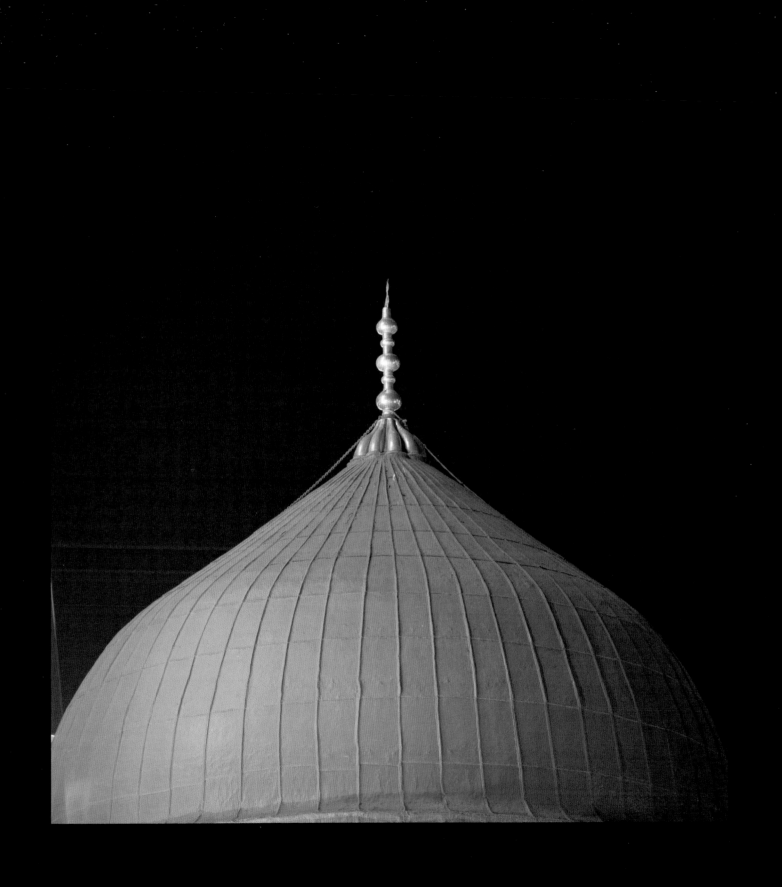

HANDS OF LIGHT

When My servants ask you about Me, indeed I am near.
I answer the prayer of the asker when he prays to Me.

The Quran, 2:186

**THE PROPHET'S MOSQUE
MADINAH THE ILLUMINATED
KINGDOM OF SAUDI ARABIA**

One of my favorite places to photograph is inside the Prophet's
Mosque in Madinah. I am extremely grateful for having been
allowed to photograph there on many occasions. You see such
extraordinary people from every ethnic background quietly
worshipping in the mosque. I am acutely aware of the problem
of imposing upon people's private moments, so I always try to be
as discreet as possible. This man was so lost in his prayer that
he did not notice me taking this photograph.

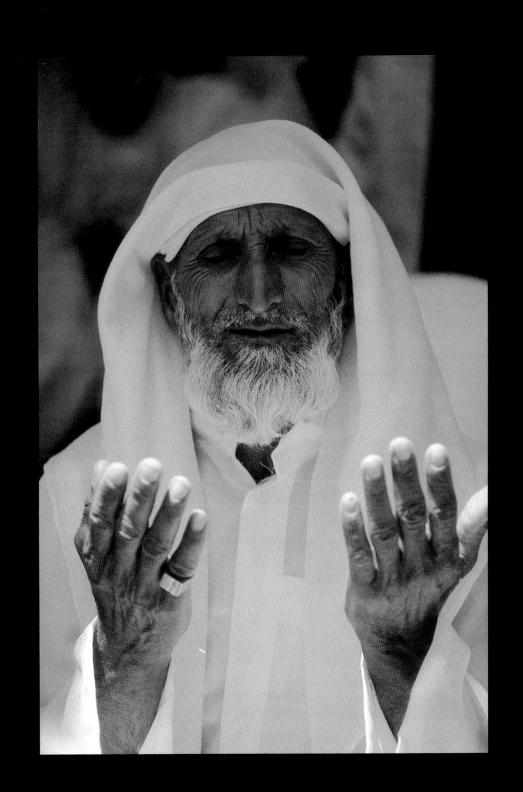

FACES OF MADINAH

A smile is charity.

The Prophet Muḥammad ﷺ

TRADITIONAL BAKERY
MADINAH THE ILLUMINATED
KINGDOM OF SAUDI ARABIA

While in Madinah photographing the old city, I came across this
traditional bakery run by smiling Egyptians who willingly posed
for this photograph. Since the redevelopment of Madinah,
this bakery unfortunately has disappeared.

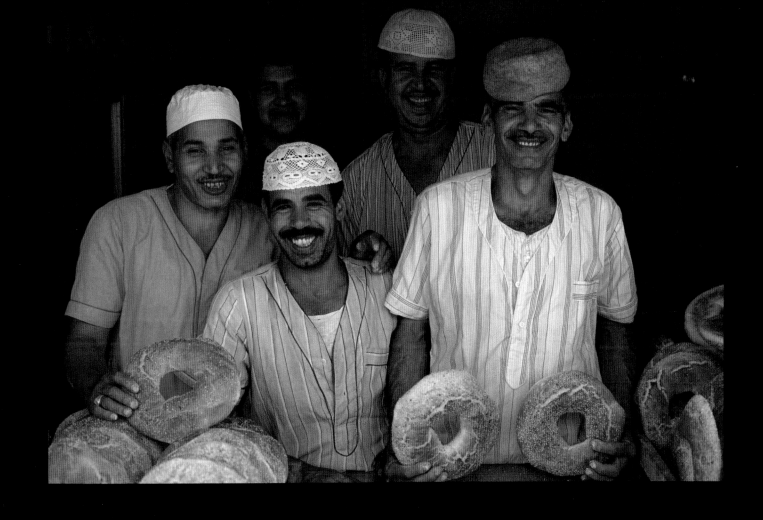

SHADOWS AND REFLECTIONS

Surely the cosmos is meanings set up in images.
Those who comprehend it are the people of discernment.

Shaykh Muḥammad ibn al-Ḥabīb

CITY OF LIGHT

MADINAH THE ILLUMINATED

KINGDOM OF SAUDI ARABIA

The white marble of the piazza area offers a great mirror image
of the people who wander across it. What is extraordinary is the
way the shadows appear denser than the bodies. Can we always
be sure that what we see is what actually is?

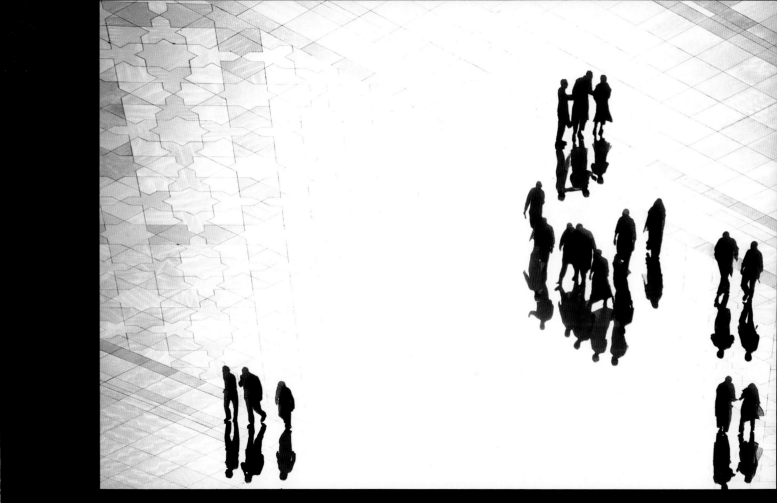

DAYBREAK REVEALS ITS HIDDEN TREASURE

By the moon,
and the night as it recedes,
and the morning as it shines forth,
this is surely one of the greatest signs.

The Quran, 74:32–35

WĀDĪ ḤAḌRAMAWT

AL-ḤAJARAYN, SOUTH YEMEN

Sacrificing our sleep, we set off at 2:30AM in order to arrive at al-Ḥajarayn in time for the dawn light. By moonlight, we found our chosen position and waited. Each degree of light brought forward hidden treasures.

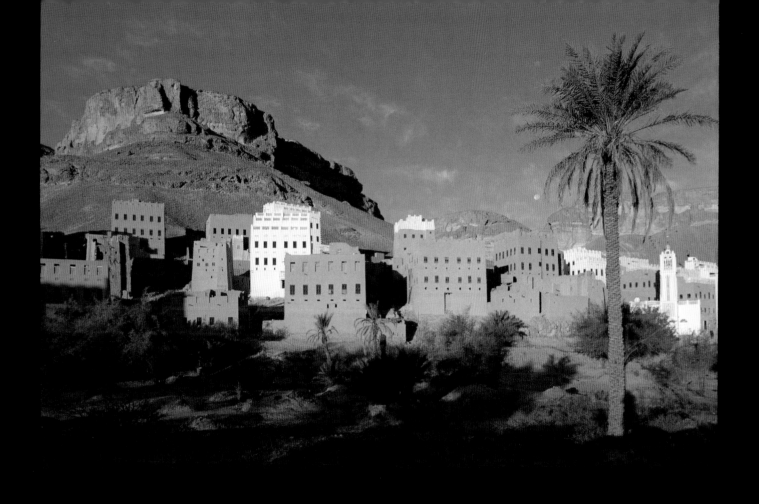

HIDDEN WORLDS

Peace be on the people.
They are protected, wherever they go.
May they enjoy it.
How excellent the place they choose to stay!

Shaykh Muḥammad ibn al-Ḥabīb

Tarīm is the home of some of the greatest scholars I have been
fortunate to meet. Here I joined the students of Tarīm as they
greeted one another after the Friday Prayer. The unusual
colored glass added to the special atmosphere.

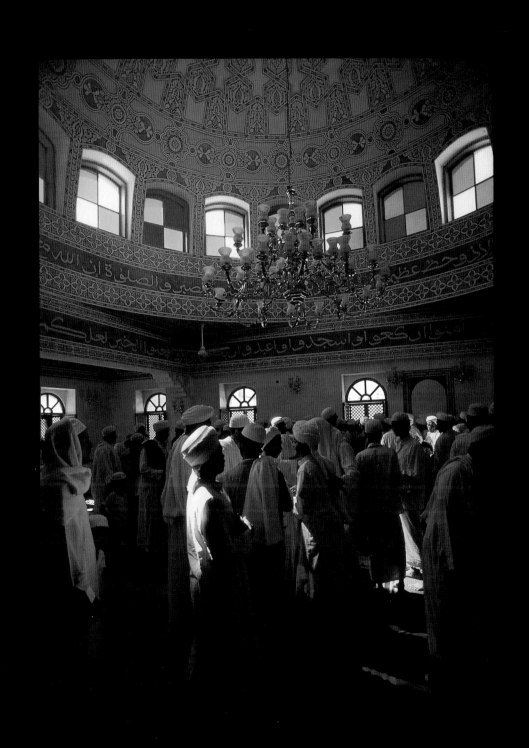

VISIT TO A PROPHET

Prophet Hūd said, "O my people, worship God. You do not have any God except Him. Will you not be God-fearing?"

The Quran, 7:65

For five days we rested in tents in this ancient place, the burial site of the Prophet Hūd ﷺ, a prophet of ancient Arabia. At night the stars were so near we thought we could touch them.

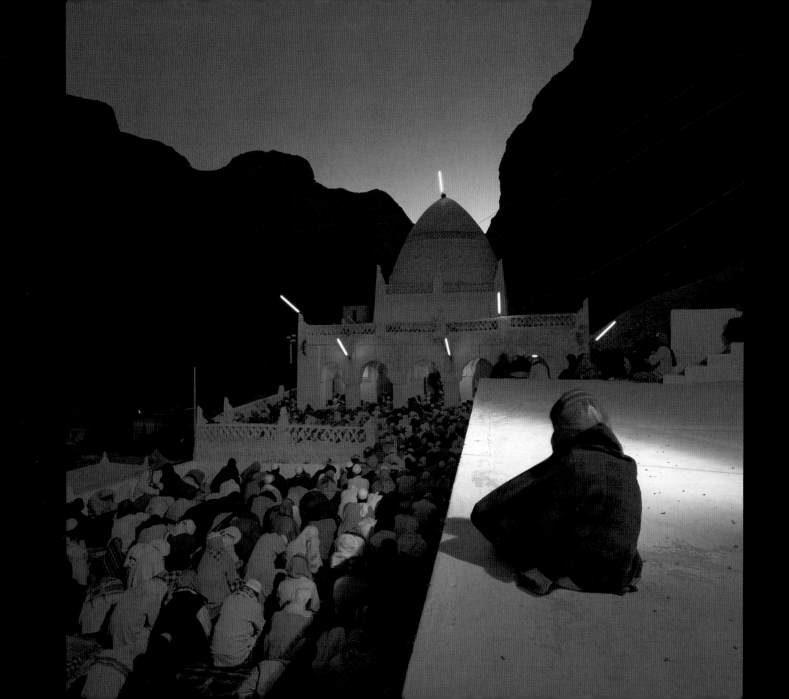

THE ENWRAPPED ONE

O you enwrapped in a cloak,
stay up at night, except a little,
half of it, a little less or a little more,
and recite the Quran distinctly.

The Quran, 73:1–4

The time between dawn and sunrise is considered a special time
for prayer. While visiting the site of the Prophet Hūd ﷺ, I saw
this pilgrim completely absorbed in worship.

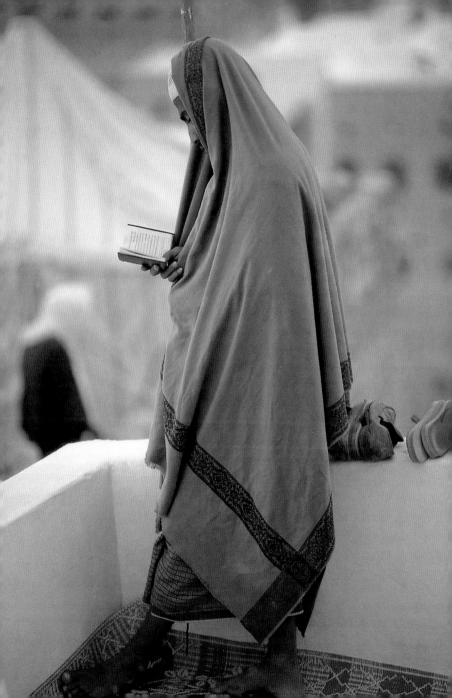

FARID – THE UNIQUE

It has been related that the first person whose hair turned white was the Prophet Abraham ﷺ (the Friend of God). Abraham asked, "O Lord! What is this?" His Lord answered, "This is dignity." So Abraham said, "Lord, give me more dignity!"

The Prophet Muḥammad ﷺ

WĀDĪ ḤAḌRAMAWT
TARĪM, SOUTH YEMEN

Occasionally, people appear within my vision whom I am completely drawn to. Photographing in Tarīm this distinguished figure seemed to manifest in front of me. I entered his presence and he allowed this intimate portrait to be taken. After finishing and moving away, I turned back and he had vanished, nowhere to be seen.

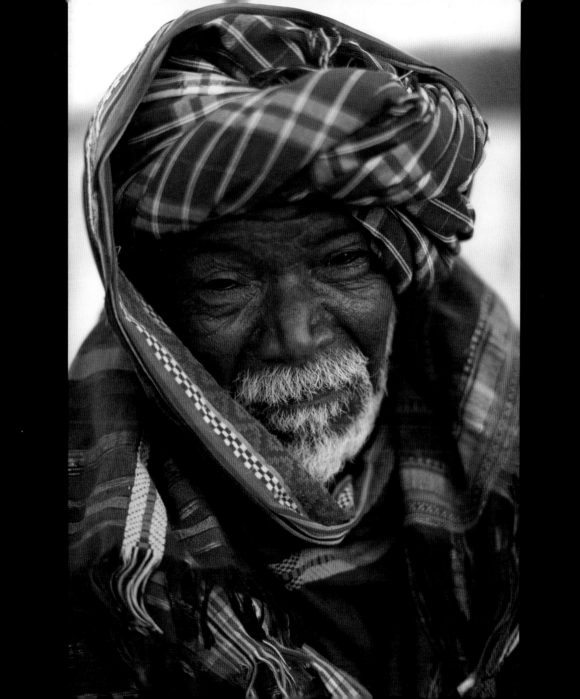

PINK GLASSES AT THE PINK BUS STOP

And among His signs is the creation of the heavens and
the earth and the variety of your tongues and your
colors. Surely, in this are signs for people of knowledge.

The Quran, 30:22

ASHGABAT DISTRICT

TURKMENISTAN

CENTRAL ASIA

We had just crossed the border from Iran into Turkmenistan,
but not without some difficulty. I was happy when I caught
sight of this impressive figure standing at a pink bus stop and
wearing pink glasses. I implored my colleagues to stop. We
struck a deal: in return for allowing me to photograph him, we
gave him a ride to his destination. He looked quizzically at his
new-found traveling companions and then proceeded to praise
God non-stop for the rest of the journey.

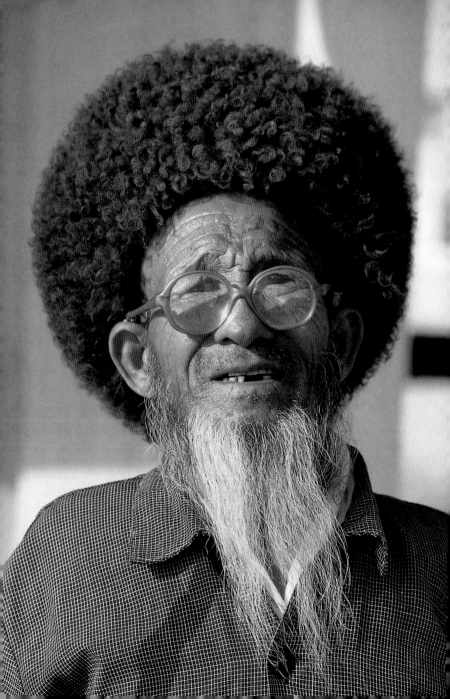

PROVISIONS ON THE ROAD

The earth fulfilled her trust
providing provisions,
by the permission of her Creator,
for creatures great and small.

From *The Burda* of Imām al-Buṣayrī

Along the Silk Route to the ancient city of Merv, once one of
the world's greatest cities, we stopped to purchase some apples
for our breakfast. It was with great dignity and modesty that
this Turkmen woman granted my request to photograph her.

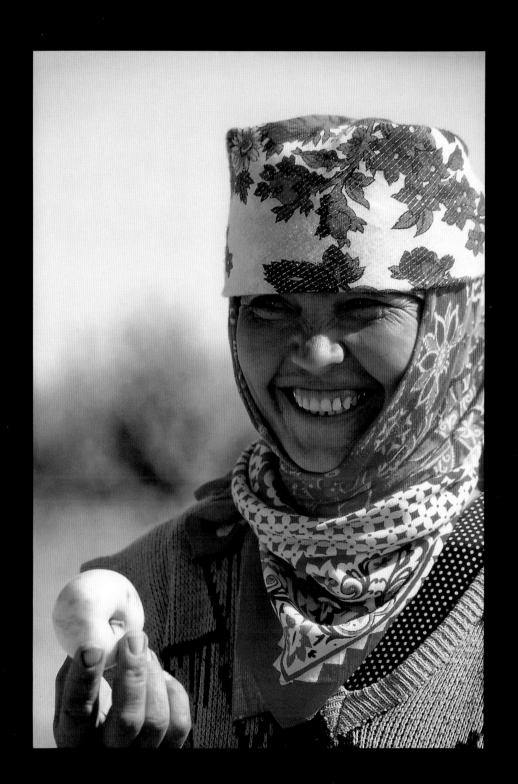

THE CHILDREN OF THE SILK ROUTE

I love children. They are content with the least of
things, and gold and mud are the same in their eyes.

The Prophet Muhammad ﷺ

ASHGABAT, TURKMENISTAN

CENTRAL ASIA

Traveling by land along the Silk Route, we entered
Turkmenistan and rested in the capital Ashgabat, which means
"The City of Love." Each evening as the intense heat of the day
eased, I would sit and talk to the local children playing outside
my hostel. Photographing them, I was able to
glimpse worlds within worlds.

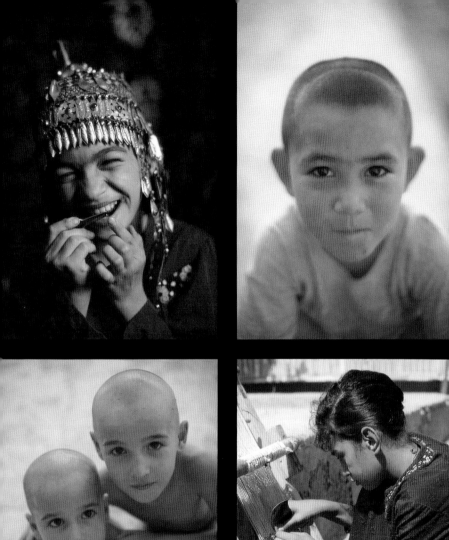
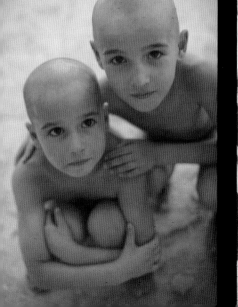
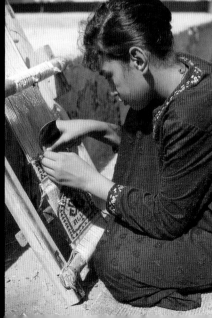

THE WEDDING

He who marries secures half of his religion.

The Prophet Muḥammad ﷺ

My search for a traditional wedding in Turkmenistan took us on a long drive through the outskirts of Merv (presently named Mary). Once we had permission, I was allowed into the house to set up my equipment. I had assumed that I would be photographing only the bride and groom, so imagine my surprise when this whole entourage of women and children came in and sat in front of me.

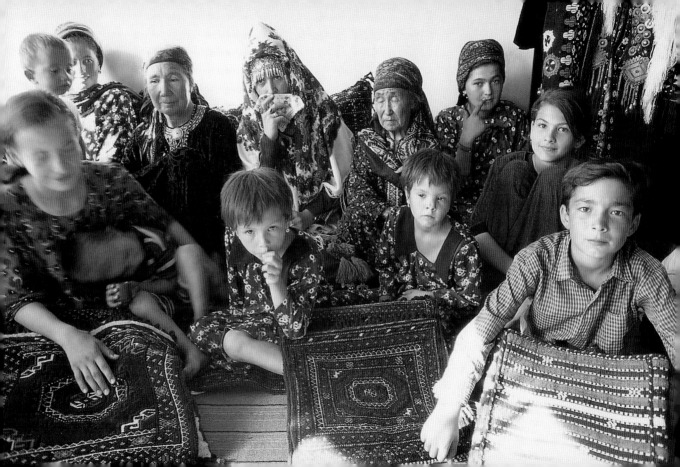

XIAN AND BEIJING'S OLDEST MOSQUES

Seek knowledge even in China.

The Prophet Muḥammad ﷺ

[ABOVE] THE MOSQUE AT DAXUEXI LANE
XIAN, SHANXI PROVINCE, CHINA

Situated at "Big Learning Lane" established in 706 AD, Muslims
were in this ancient capital only 60 years after the Prophet's
migration to Madinah. Within this building, I found elements of
a Zen monastery and feng shui, as well as being a mosque.

[BELOW] NIUJIE MOSQUE
BEIJING, CHINA

Beijing's oldest mosque is over 1000 years old. Out of respect
for this beautiful building, it is constantly cleaned, swept,
and polished.

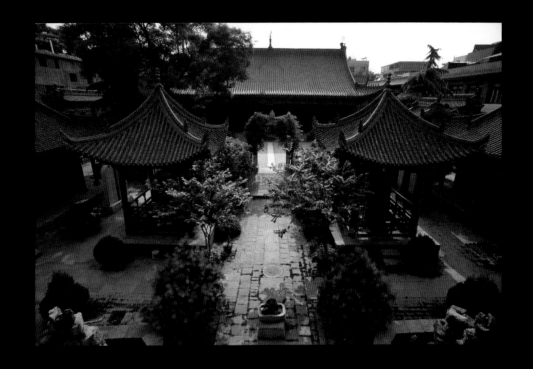

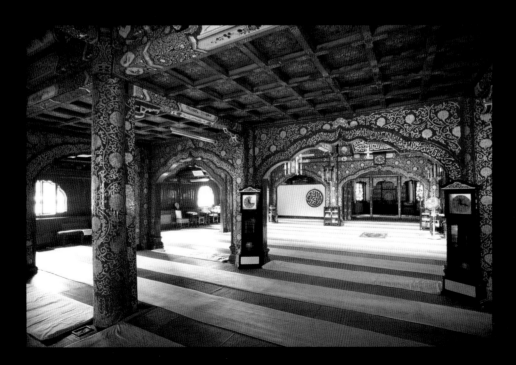

SERVICE AND STUDY

One does not acquire learning nor profit from it, unless
one holds knowledge in esteem and those who possess it.

Imām al-Zarnūjī

[ABOVE] IMĀM ḤAJJĪ YŪSUF
BAOQI, SHANXI PROVINCE, CHINA

I had longed to visit China since the 1970's. The meeting of two
great cultures was of great interest to me—Islam in China.
Twenty-five million Muslims is the unofficial figure. I finally
managed to travel there in the year 2000. For one hour, Ḥajjī
Yūsuf served us food and drink. For fifty years, though, he has
served his community as an *Imām* (religious teacher).

[BELOW] GIRLS SCHOOL
HOHHOT, INNER MONGOLIA, CHINA

In a very humble dwelling, I found these young students
spending their days learning the Quran and studying Islam.

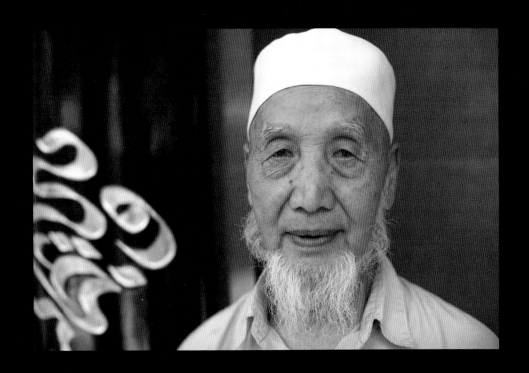
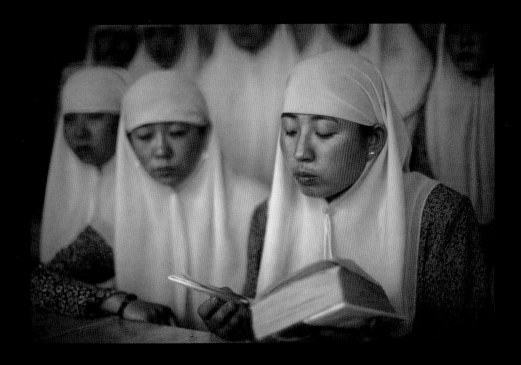

THE LIVES OF WOMEN

I am in this world like a traveler who
takes shade under a tree, only to resume his journey.

The Prophet Muḥammad ﷺ

The Lives of Man, a book by the great Ḥaḍramawtī scholar Imām
ʿAbdallāh al-Ḥaddād, examines the journey of the soul through its
different stages in this life and the next. From this
came the idea for this set of pictures.

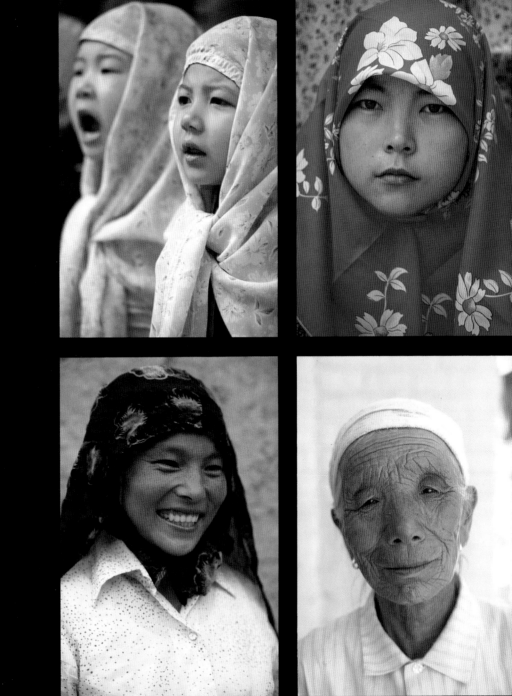

All children are the beloved of God.

The Prophet Muḥammad ﷺ

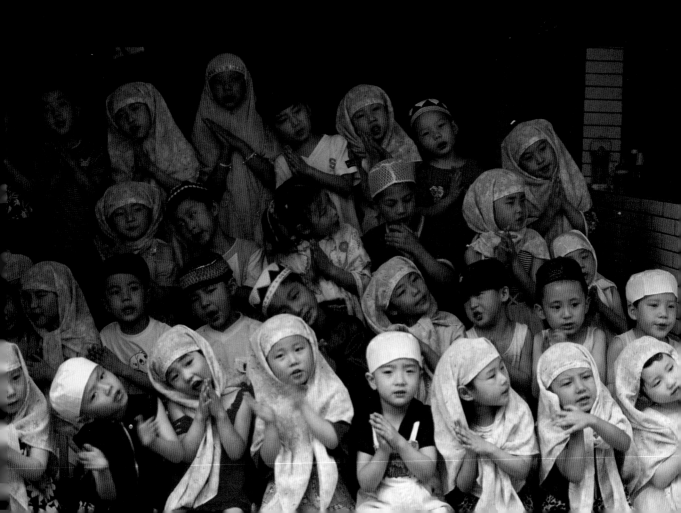

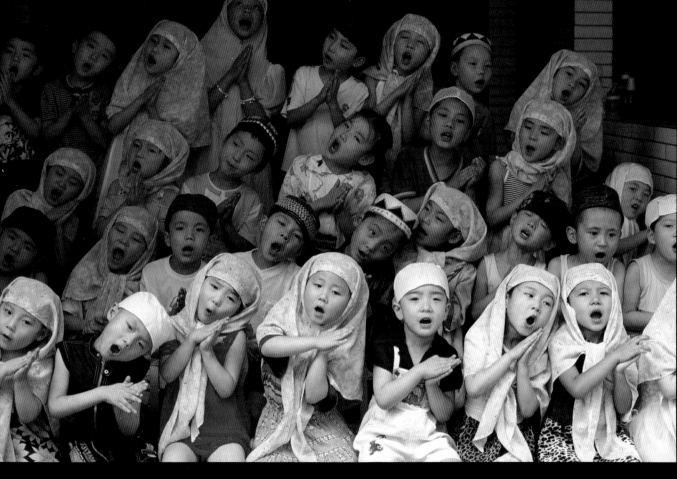

While visiting the ancient city of Xian, I was taken through the narrow streets to visit a school for 2-6 year olds. For forty-five minutes they enthusiastically recited Quran, sang songs, and utterly mesmerized me! The faces of these children

ACKNOWLEDGEMENTS

Islam teaches that as well as thanking the Creator we should also thank creation. I would therefore like to thank all my teachers who showed me so much patience, generosity, and compassion. I should also include all these people who appear in this book, as well as the many other thousands of people I have photographed over the years, for allowing me into their lives.

My gratitude is extended to Ateed Riaz without whose encouragement, constant support, and generosity, this project would never have begun. Ian Whiteman for his wonderful design. Muhammad al Mukhtar Sanders for his scrupulous attention to detail. Sīdī Hamza Yusuf for his invaluable help with some of the quotes and for occasionally carrying my camera bags. The Starlatch Press for having the courage to see the process through to the end. Finally to my wife Hafsa and the rest of my family for putting up with my long periods of absence.

The Burda (The Poem of the Cloak) by Imām al-Buṣayrī
Translated by Hamza Yusuf, Sandala Ltd. (FORTHCOMING)

The Diwans of the Darqawa (Dīwān of Shaykh Muḥammad ibn al-Ḥabīb)
Translated by 'Aisha 'Abd ar-Rahman at-Tarjumana, Diwan Press, 1980

Key to the The Garden by Ḥabīb Aḥmad Mashhūr al-Ḥaddād
Translated by Mostafa al-Badawi, Quilliam Press, 1990

Instruction of the Student: The Method of Learning by Imām al-Zarnūjī
Translated by G.E. Von Grunebaum & Theodora M. Abel, Starlatch Press, 2001

PETER SANDERS PHOTOGRAPHY WEB SITE: www.petersanders.com